THIS IS A NEW YORK REVIEW COMIC
PUBLISHED BY THE NEW YORK REVIEW OF BOOKS
435 Hudson Street, New York, NY 10014
www.nyrb.com

Mitchum by Blutch
Copyright © Blutch & Éditions Cornélius 2005–2017.
Rights arranged through Nicolas Grivel Agency
Translation copyright © 2020 Matt Madden.
All rights reserved.

Library of Congress Control Number:2019946632

ISBN 978-1-68137-444-4

Printed in South Korea
10 9 8 7 6 5 4 3 2 1

BLUTCH
MITCHUM

Translation by Matt Madden

English Lettering by Dean Sudarsky

NYRC

New York Review Comics · New York

Mitchum
numéro 1
Edité par
Cornélius
100, rue de la
Folie-Méricourt
© Blutch &
Cornélius
Dépôt Légal:
1er trimestre 96
ISSN en cours

BLUTCH MITCHUM

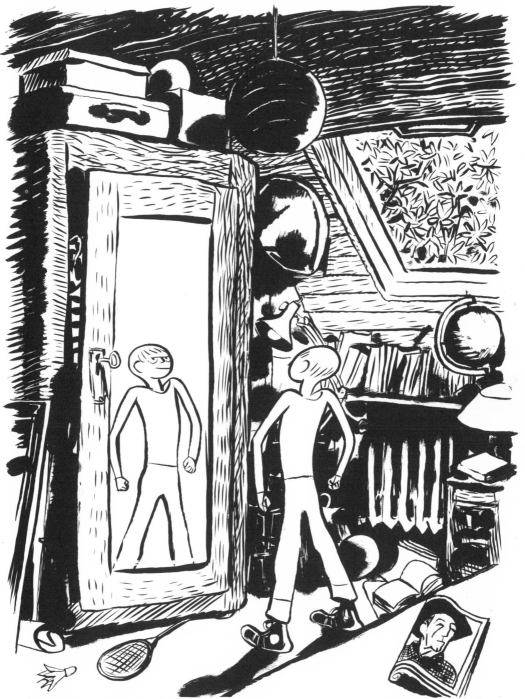

Numéro 1 ○ Éditions Cornélius ○ Collection Paul ○ 45 f.

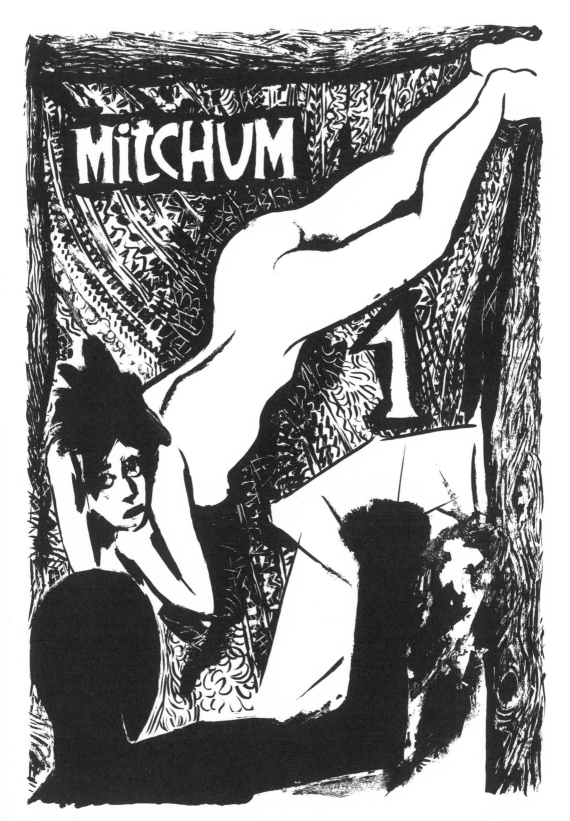

No throwing cigarette butts on the floor, the ladies will burn their feet.

HISTORY COMEDY

MANHATTAN

AND THE GOLD OF THEIR BODIES

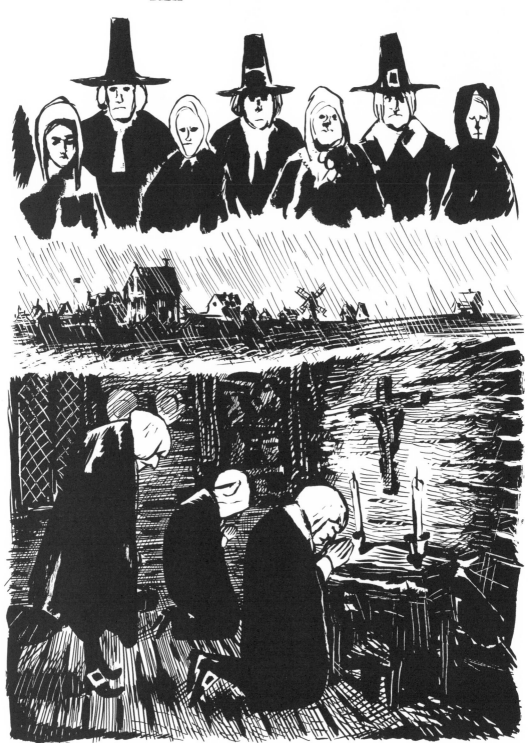

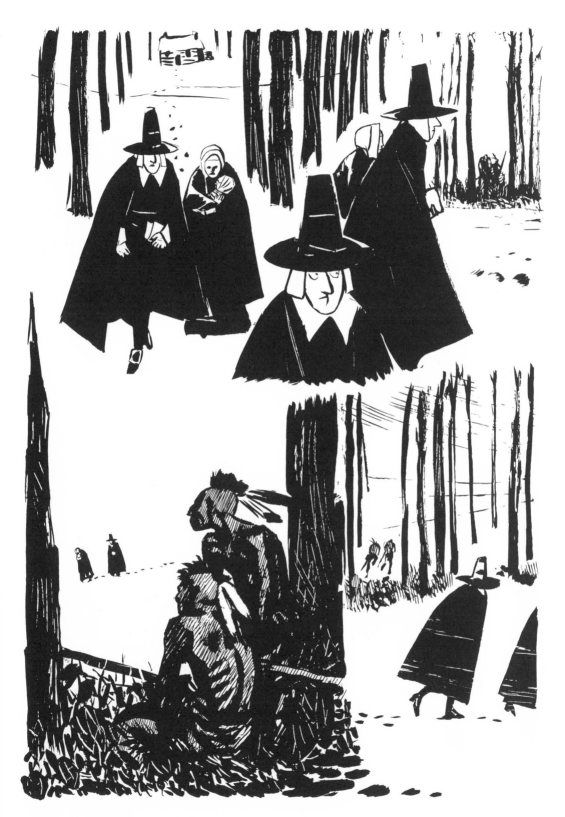

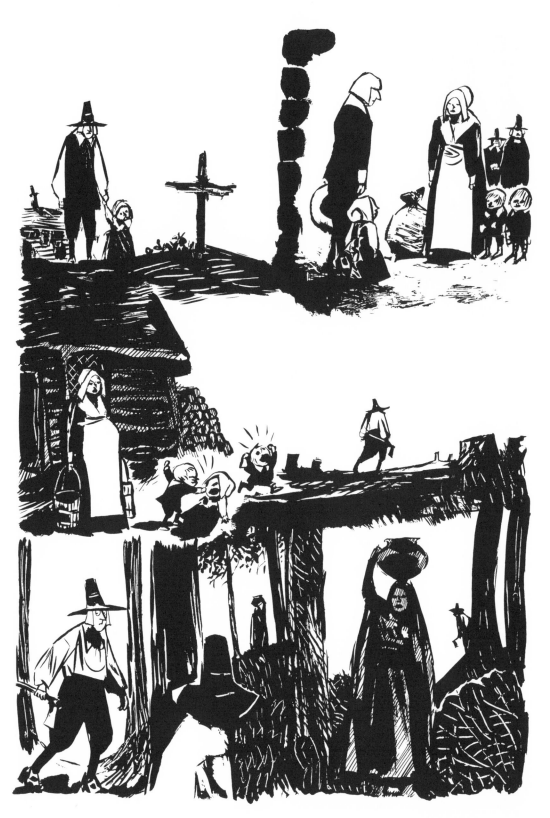

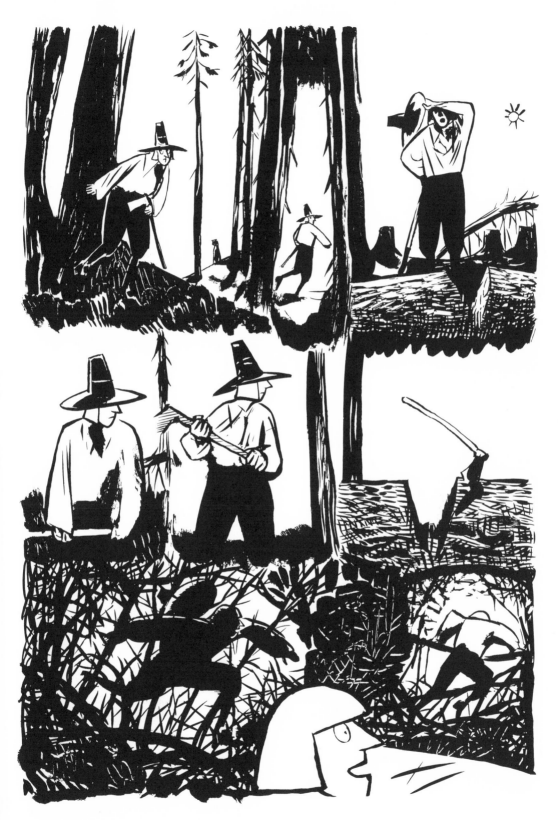

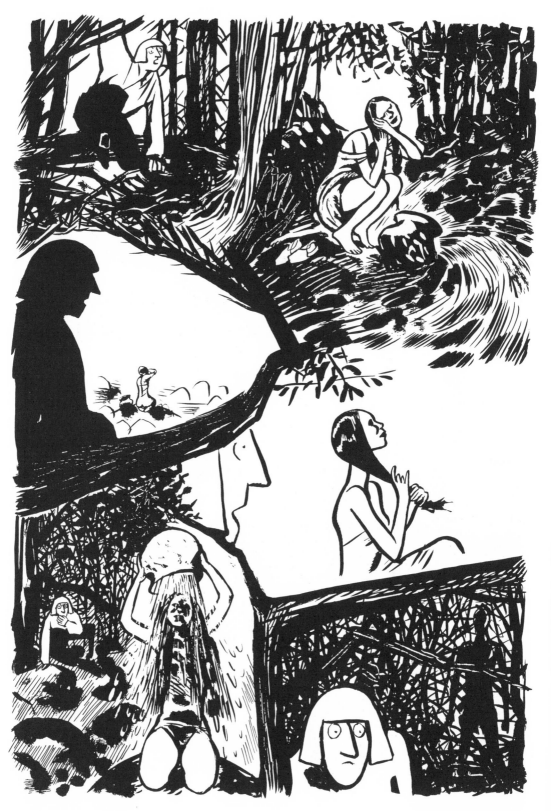

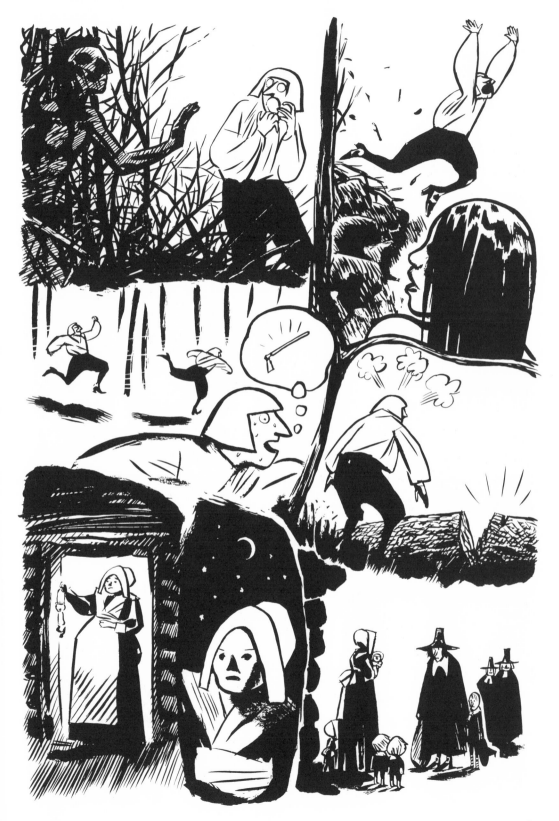

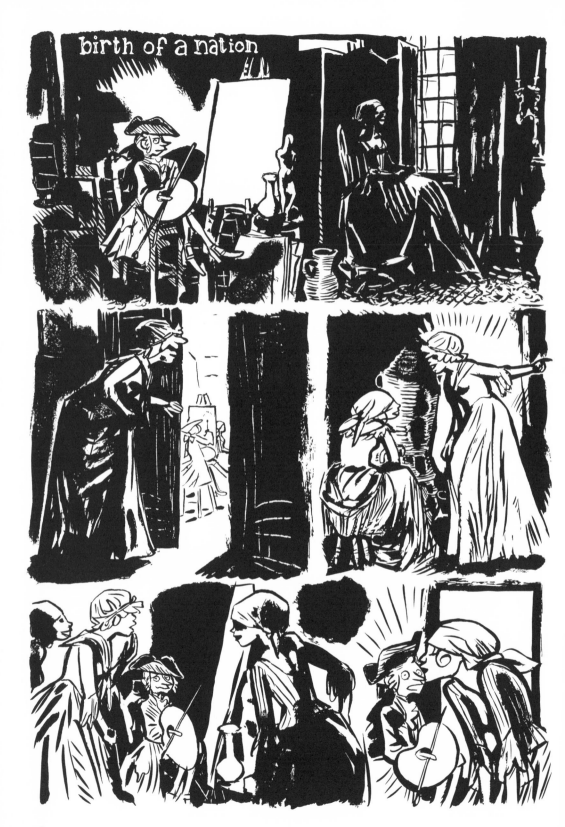

I WANT YOU

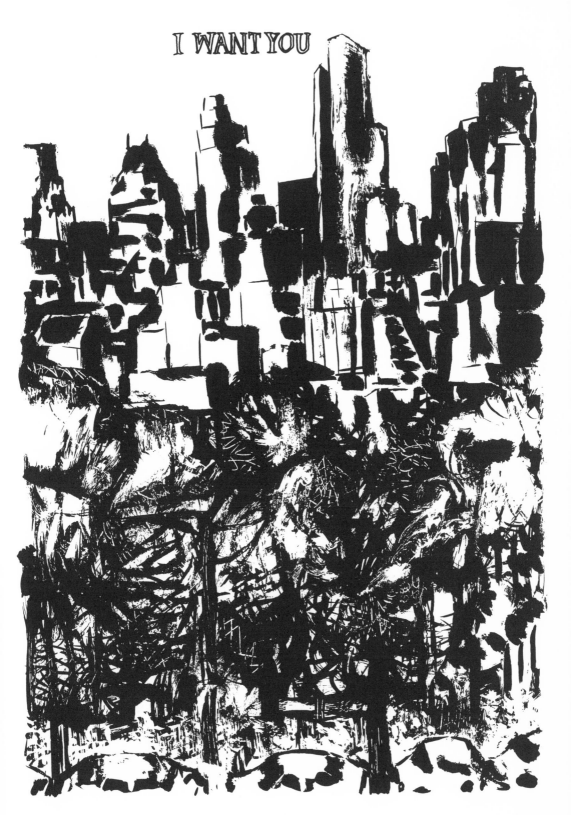

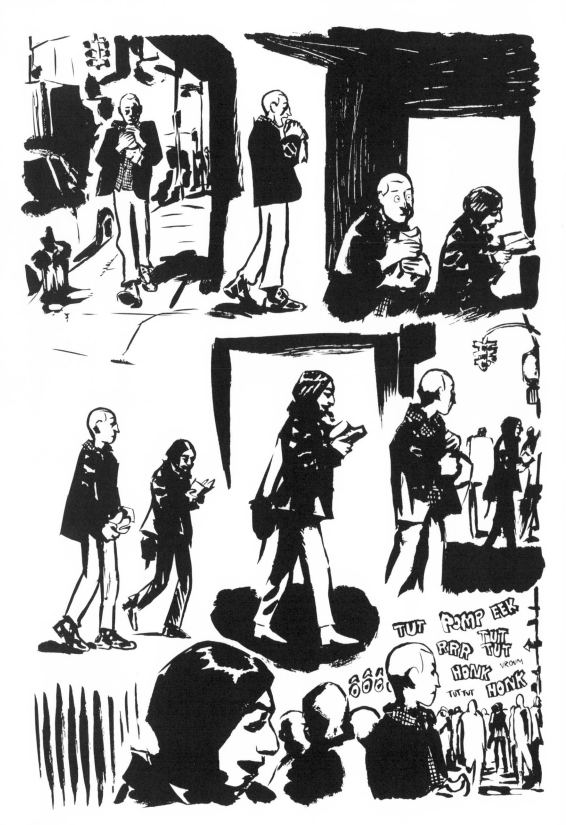

22

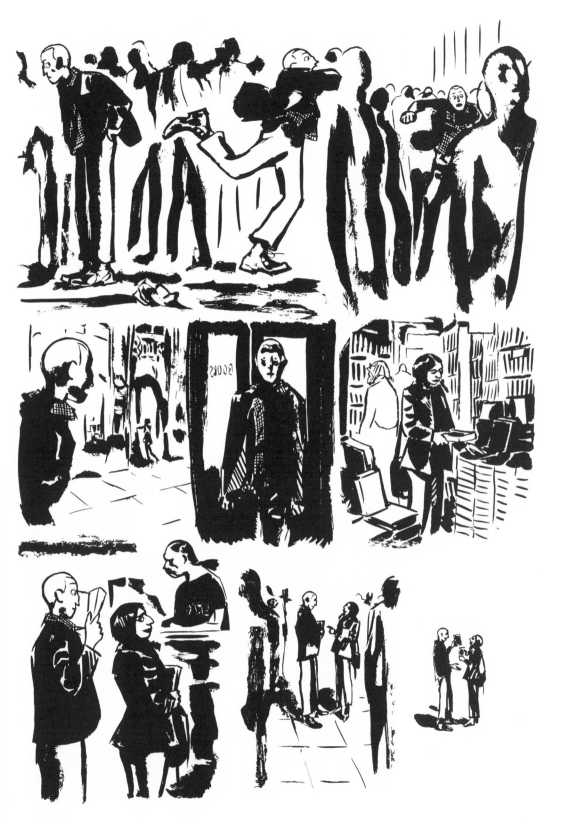

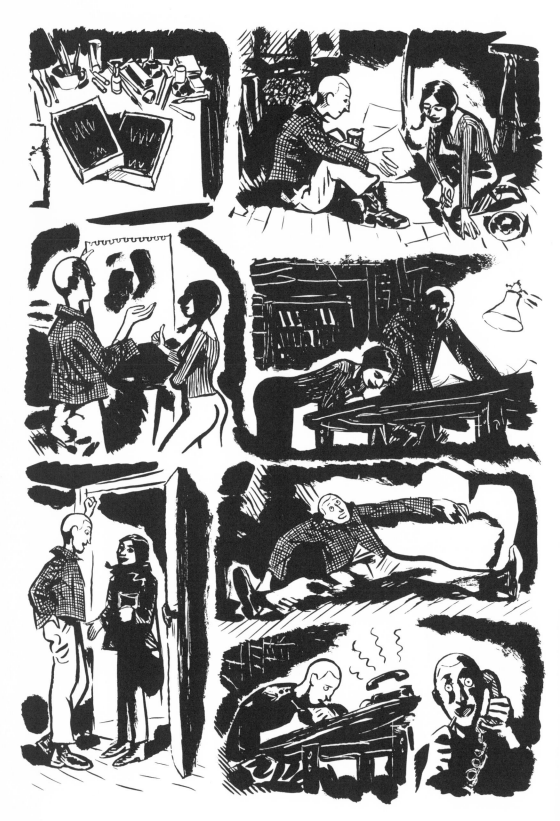

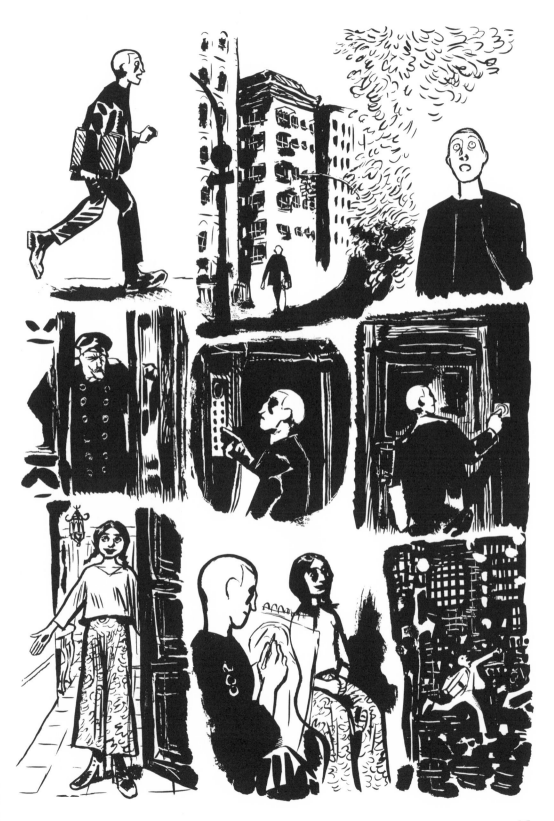

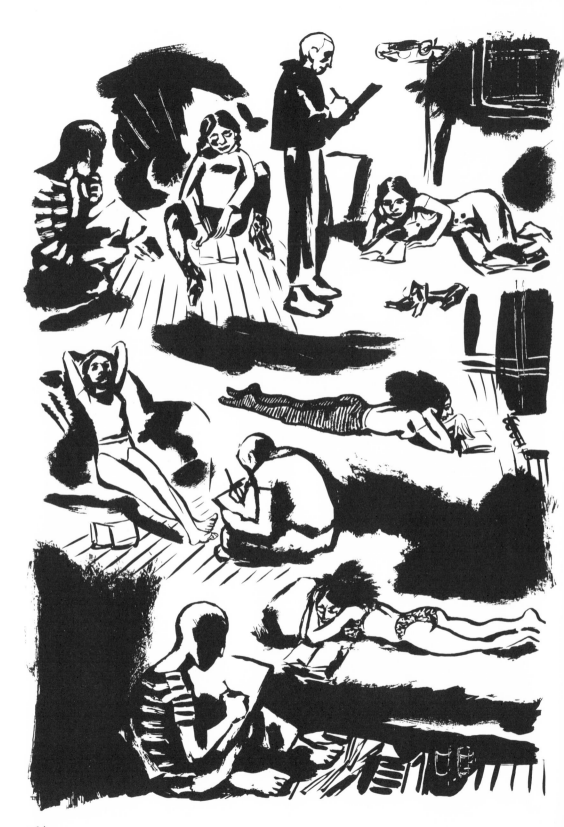

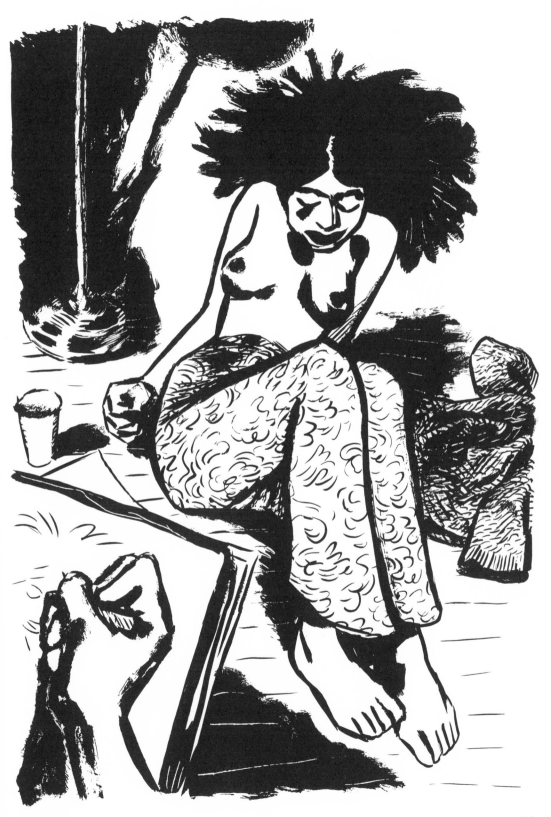

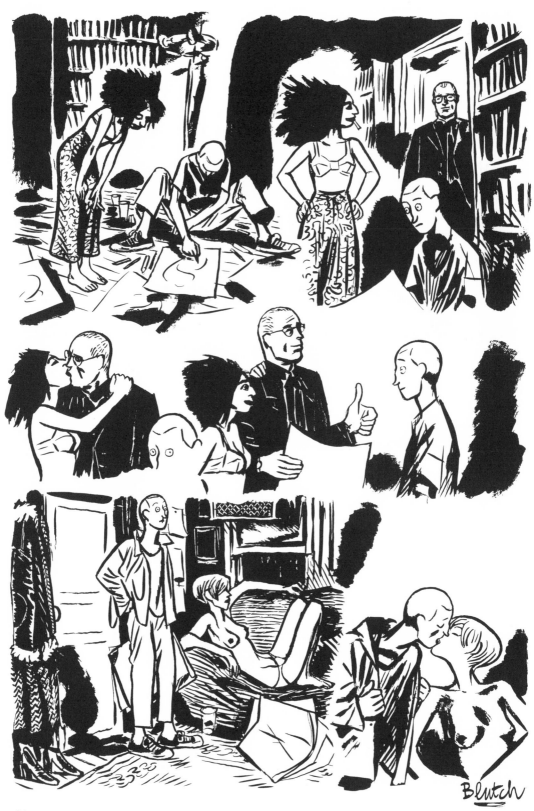

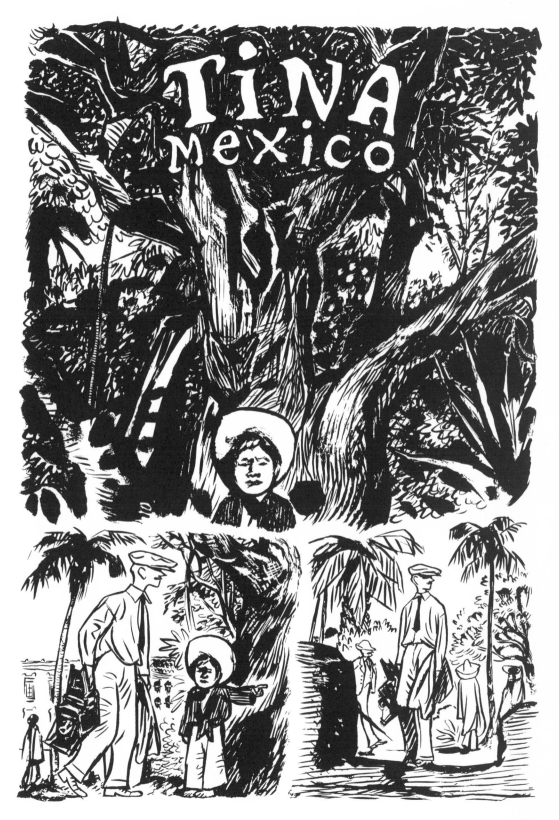

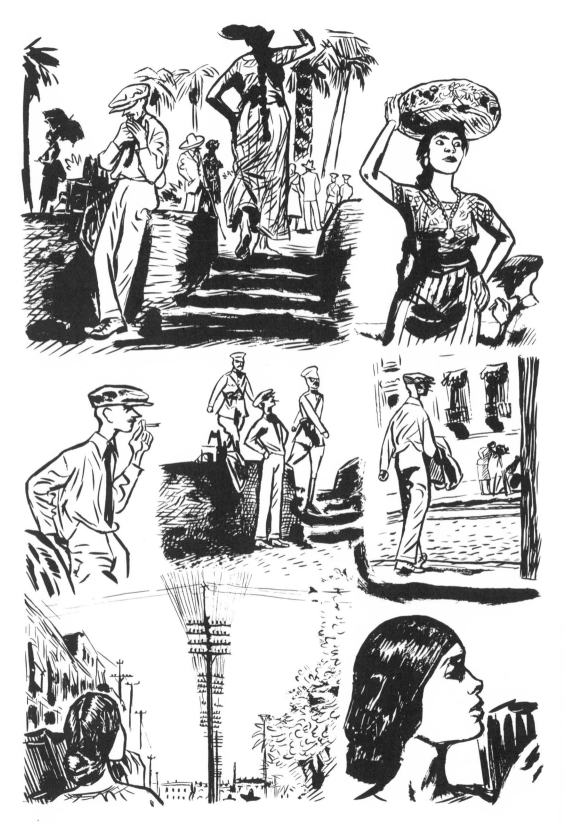

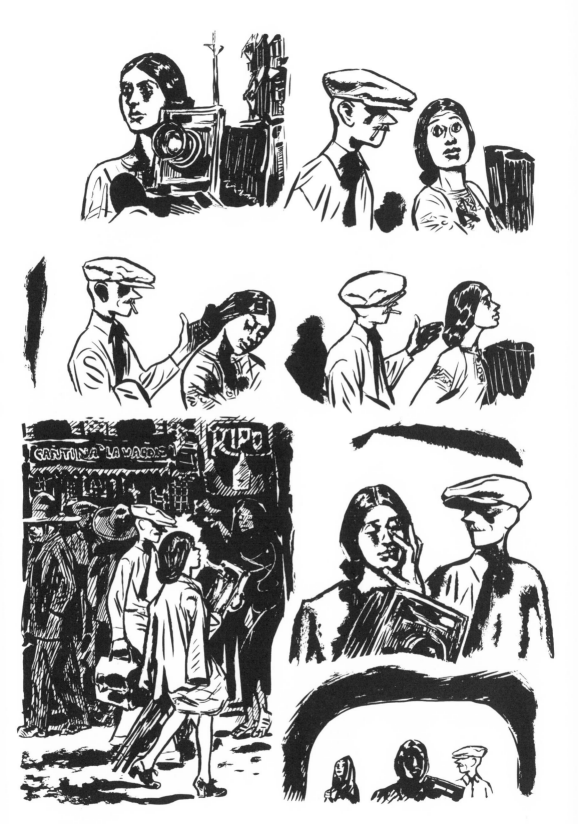

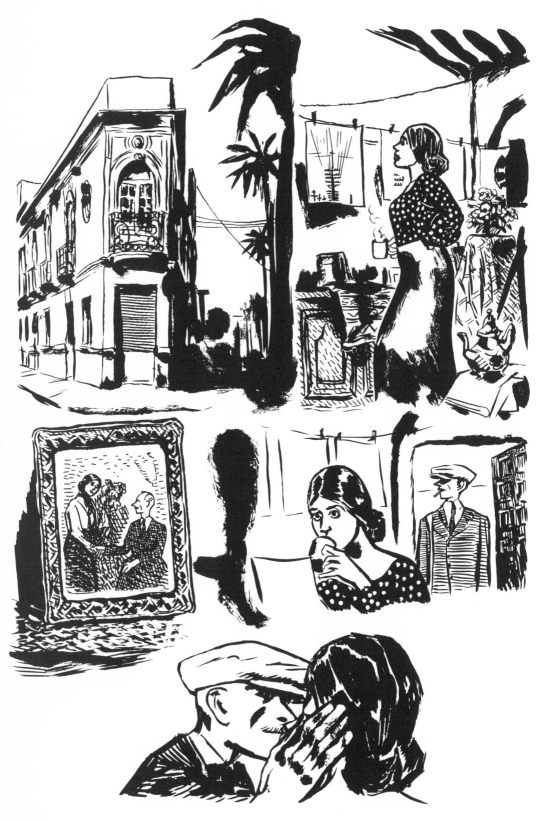

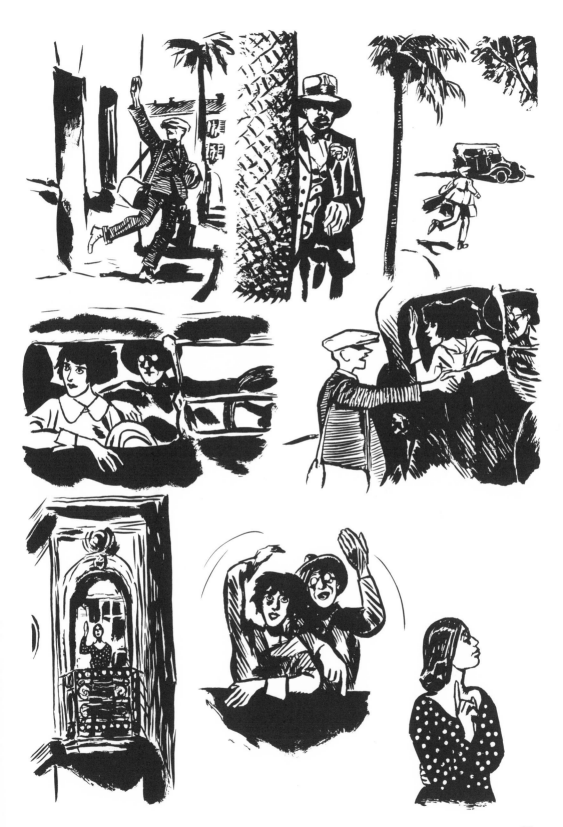

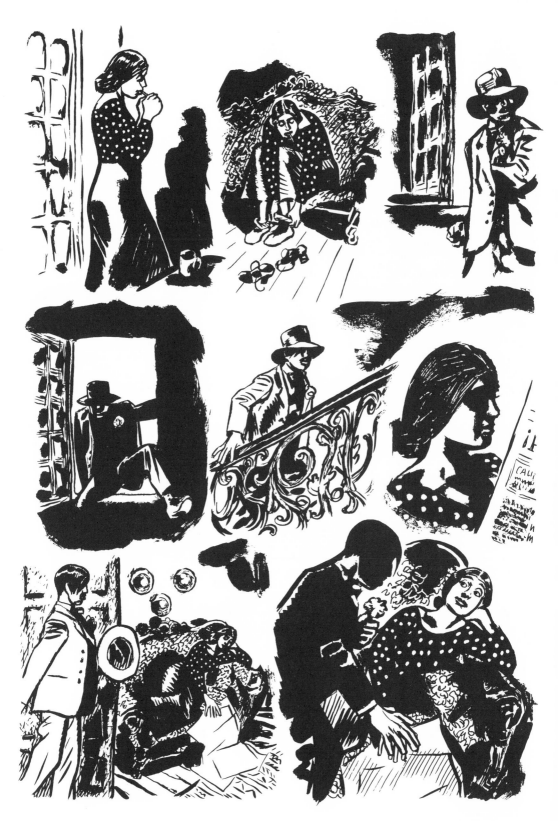

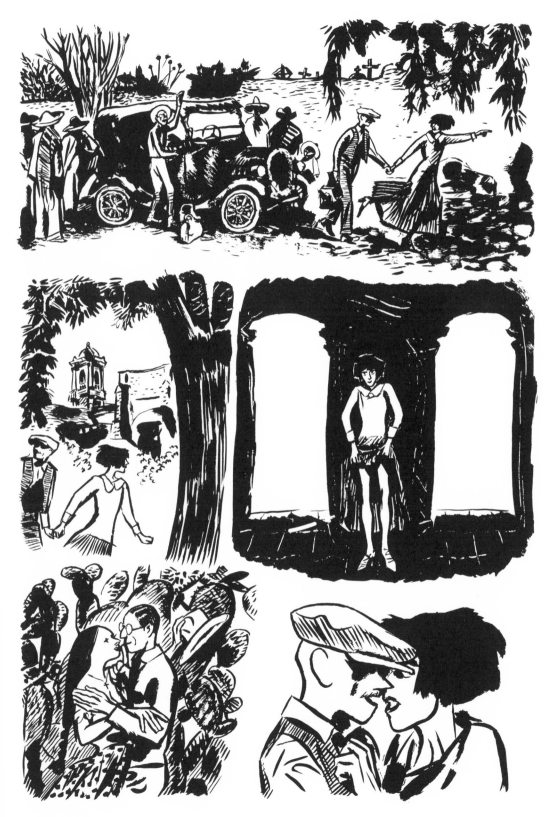

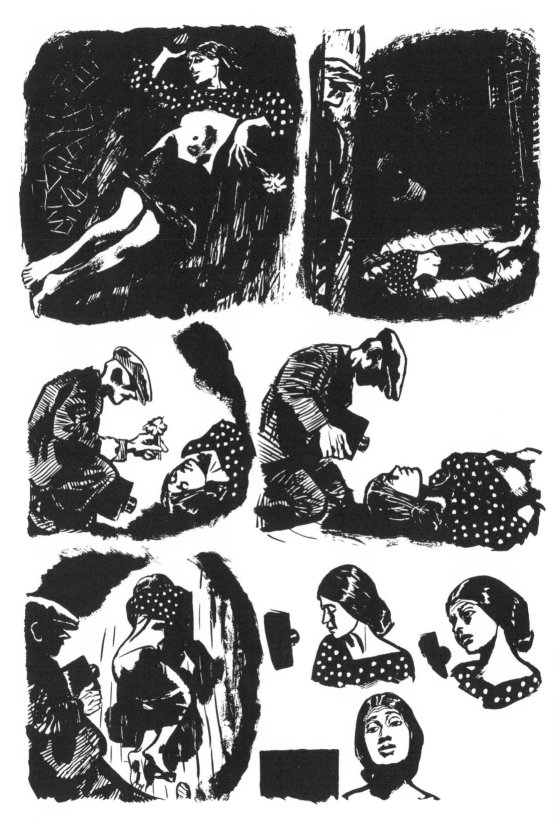

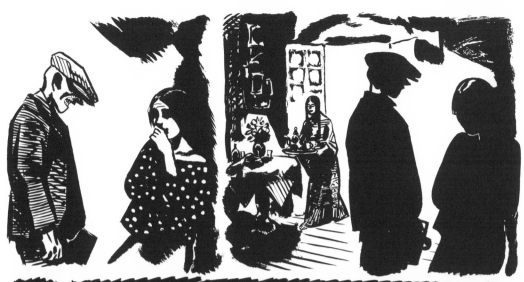

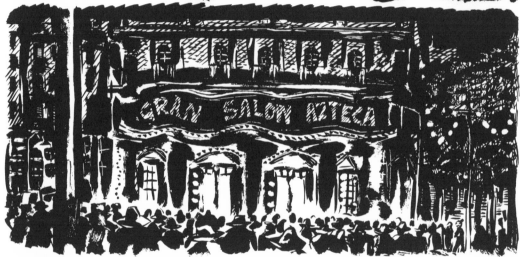

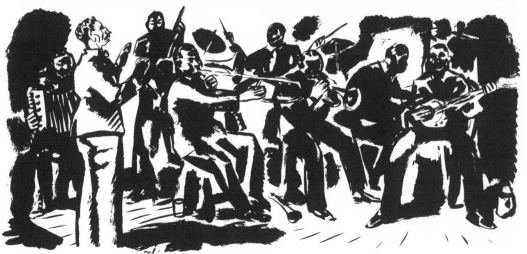

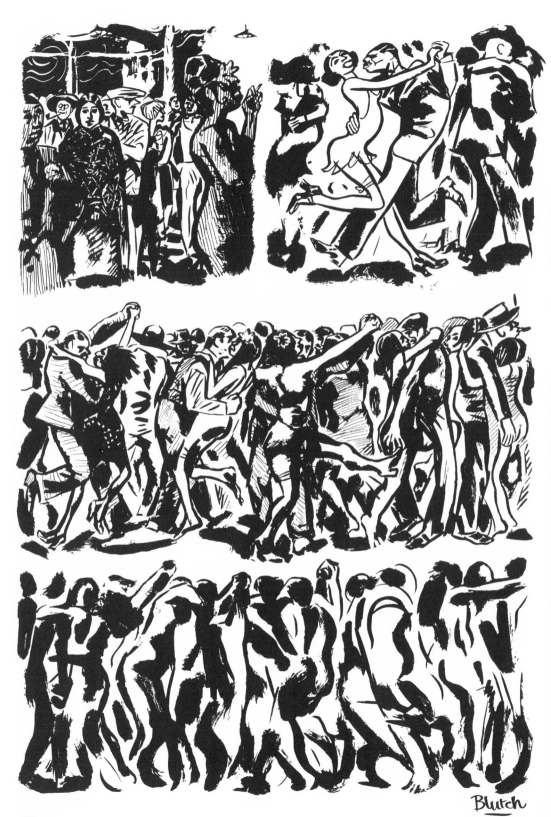

Mitchum
numéro 2
Édité par
Cornélius
100, Rue de la
Folie-Méricourt
©Blutch &
Cornélius
Dépôt Legal
4ème trimestre 96
ISBN 2-909990-20-6

Numéro 2 Éditions Cornélius Collection Paul 45f

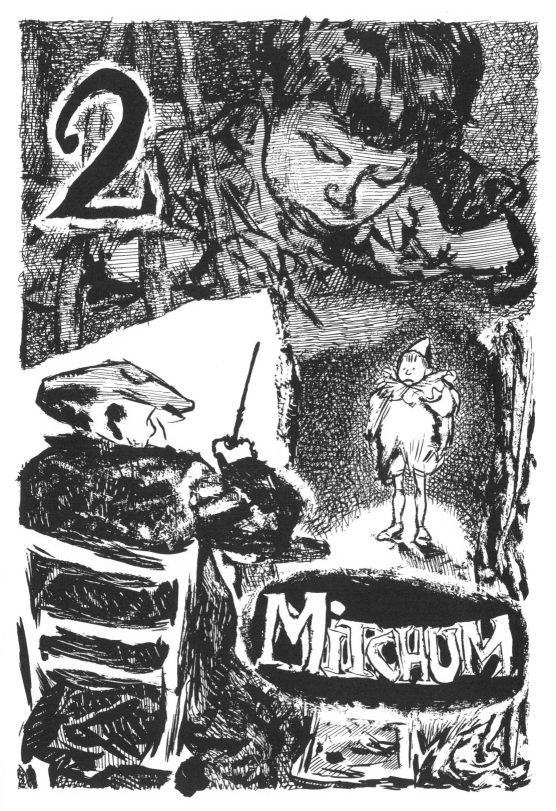

"When I think about the point-
less activities that have filled
my life, even I am flabbergasted.
Nothing but humiliating concessions!
Nothing but pointless smiles!
Nothing but renunciations, and,
above all, nothing but wasted time."
Jean Renoir
Ma Vie et Mes Films

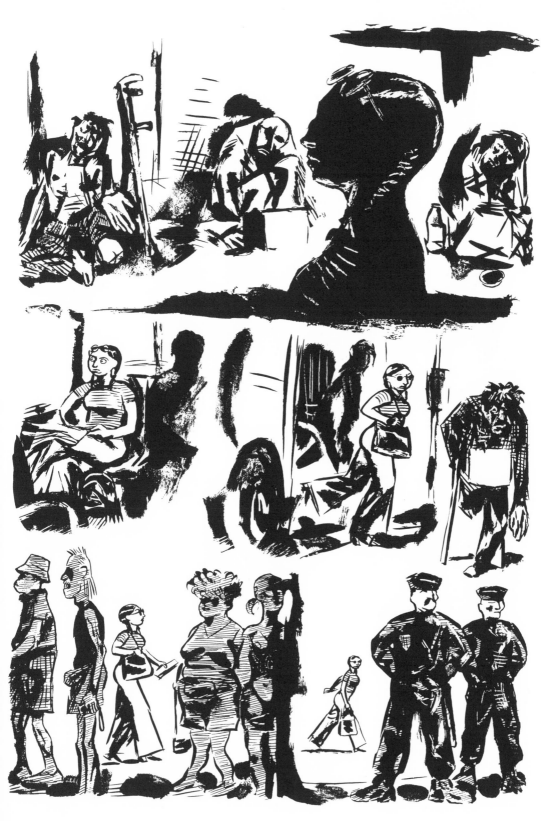

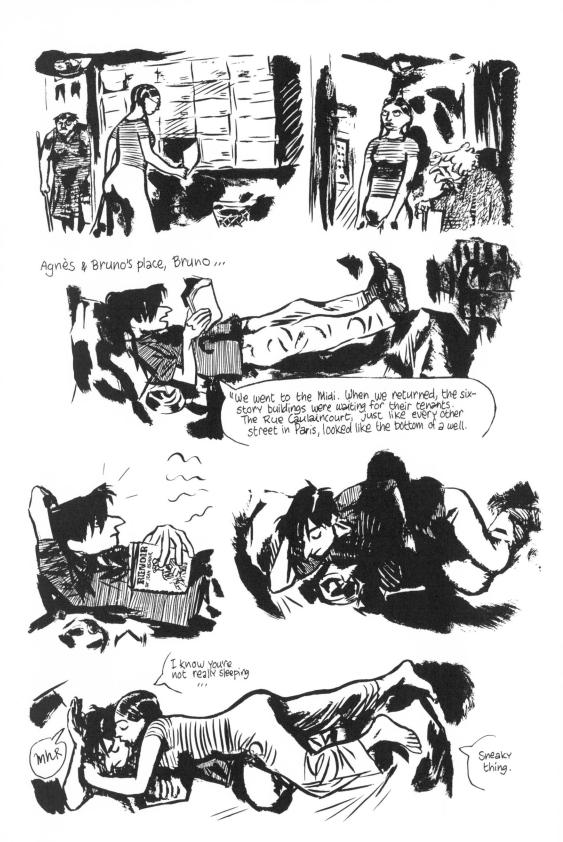

Agnès & Bruno's place, Bruno ...

"We went to the Midi. When we returned, the six-story buildings were waiting for their tenants. The Rue Caulaincourt, just like every other street in Paris, looked like the bottom of a well.

I know you're not really sleeping ...

Sneaky thing.

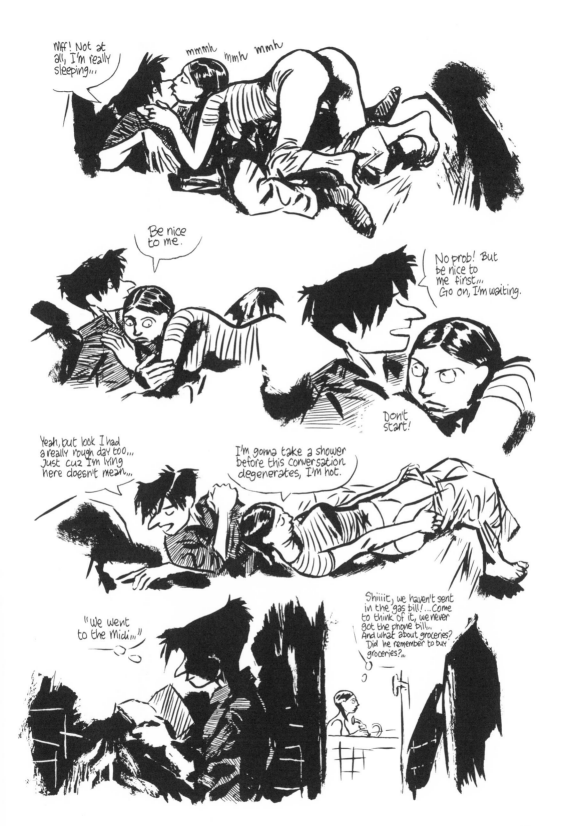

49

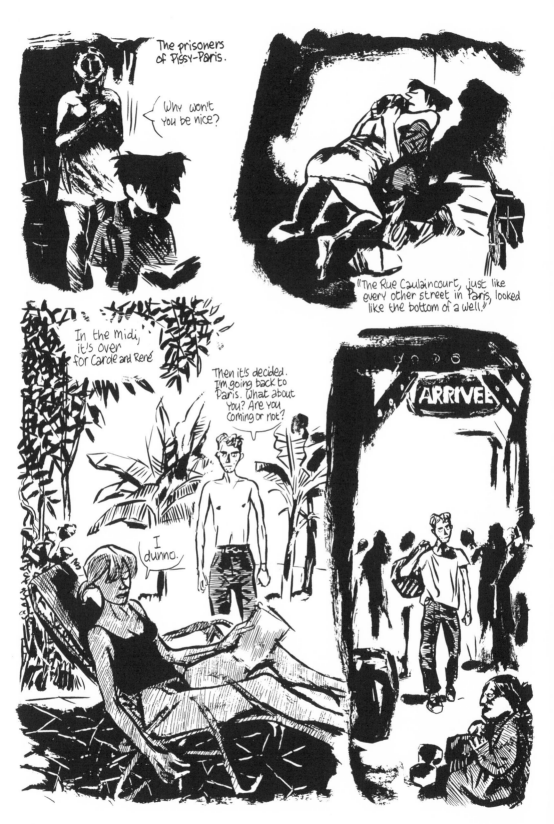

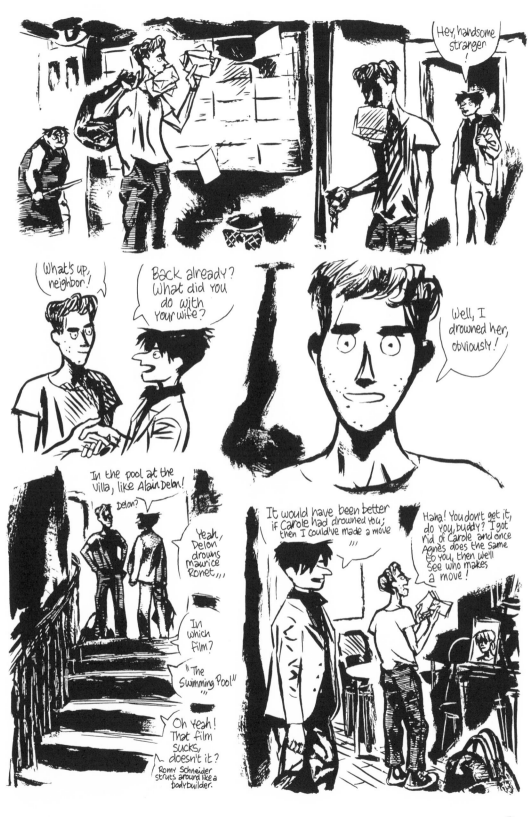

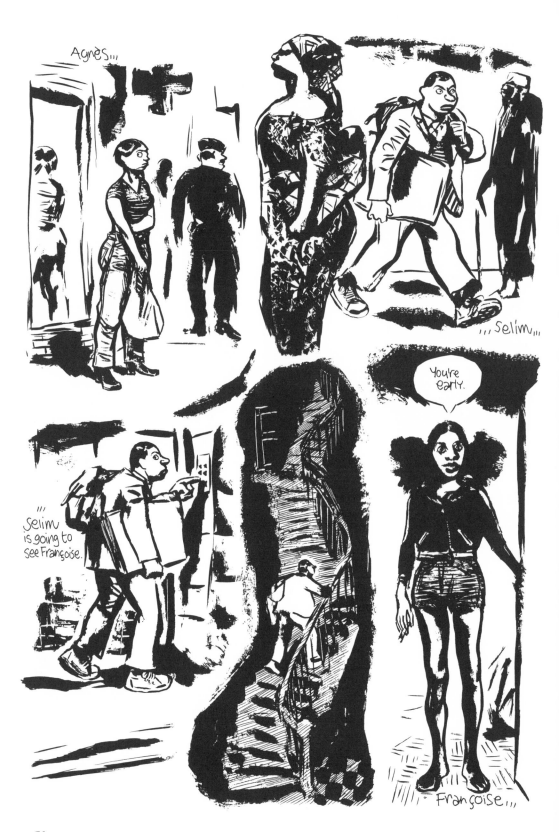

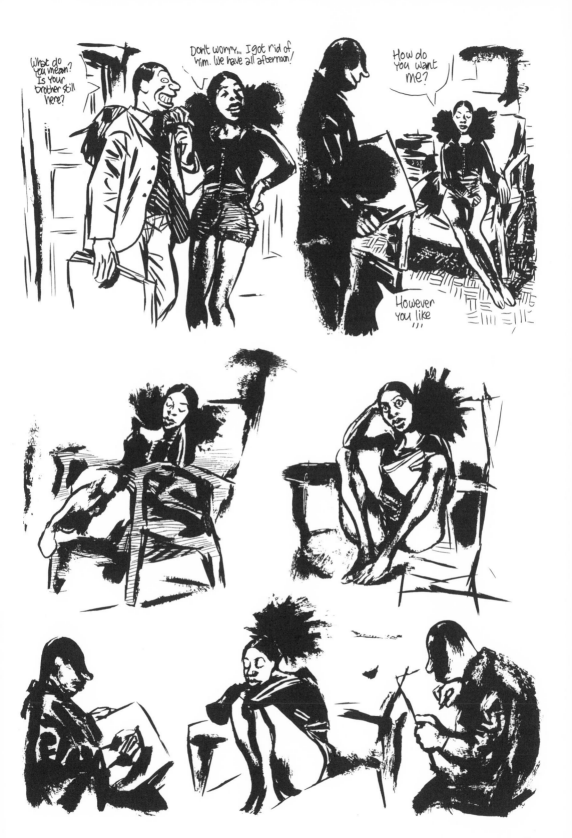

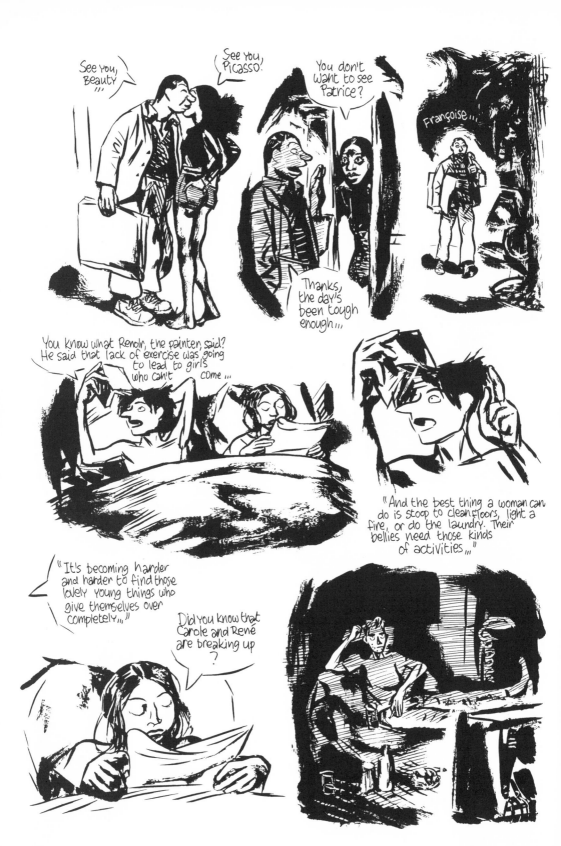

Selim thinks he's Henri
 Matisse
 ,,,

In any case, he'd like to have
his life.

"April fifth, my
dear friend ,,,,"

"You mentioned a stunning Englishwoman.
An hour ago I finished a third drawing session with
an Englishwoman who may be even more beautiful
than the one you were telling me about,,,,"

" ...mine is here and she'll be back the day after tomorrow to look me in the eyes as models tend to do while I'm working, that is to say she'll look at me defenselessly, unguardedly..."

"Her lovely, changing eyes, which seemed hazel to me yesterday, didn't seem the same color when I looked at them today..."

"...When I asked Lydia to come over, she pointed out the truth:

Her eyes are the same color as yours.

My own eyes?

I was quite surprised..."

"But over the course of the session, as I noticed her eyes change and become darker..."

"...while her face became flushed — I promise that I had nothing to do with that — it occurred to me that it was the rush of blood that caused her eyes to change color..."

"You can't possibly imagine the harmonious charm that unites her eyes, her lips, and the delicate curve of her chin..."

"I will never be able to render that. She stands before me like a little pigeon, trembling in my hand."

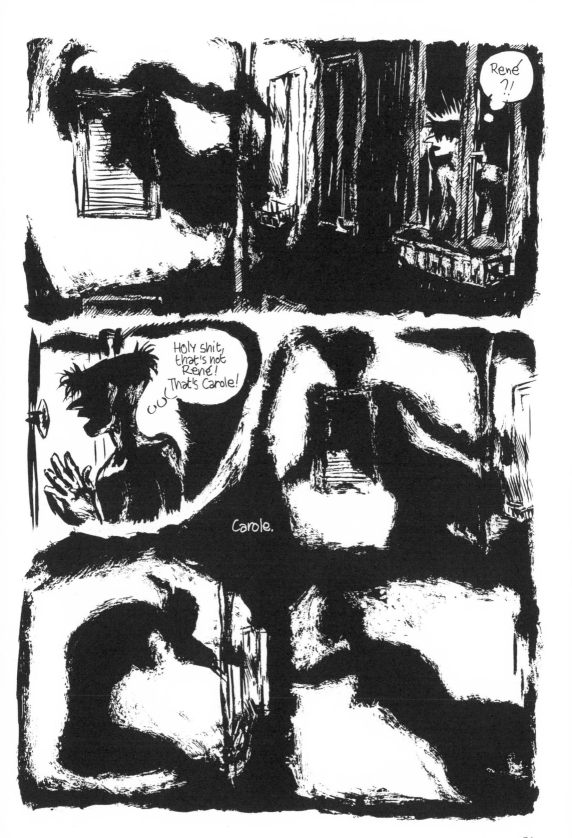

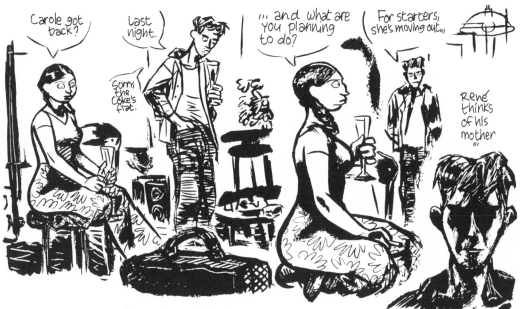

... The pathetic story of his mother who wanted to leave everything.

René and his brother were at school. She wrote a long letter explaining things to her husband. She packed her bags and left her family for good.

She and her lover had decided to run away together...

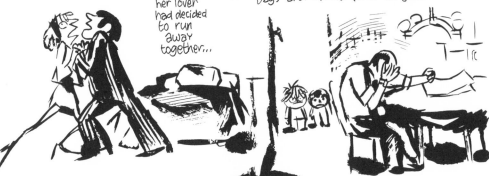

They were meant to meet at the Porte Dorée. She waited. She waited for hours but he never showed up.

It was very late when she collapsed in tears at her best friend's apartment.

The next day, she came home.

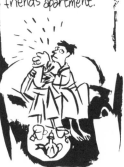

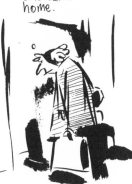

60

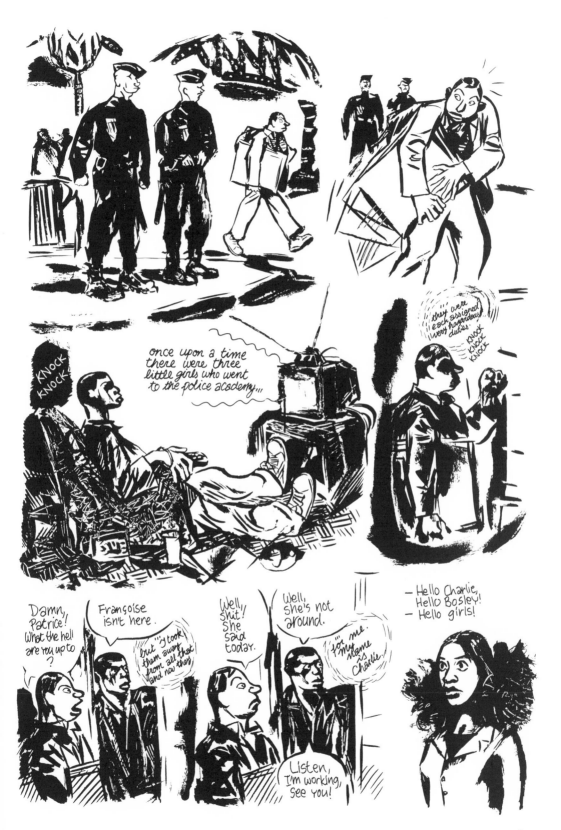

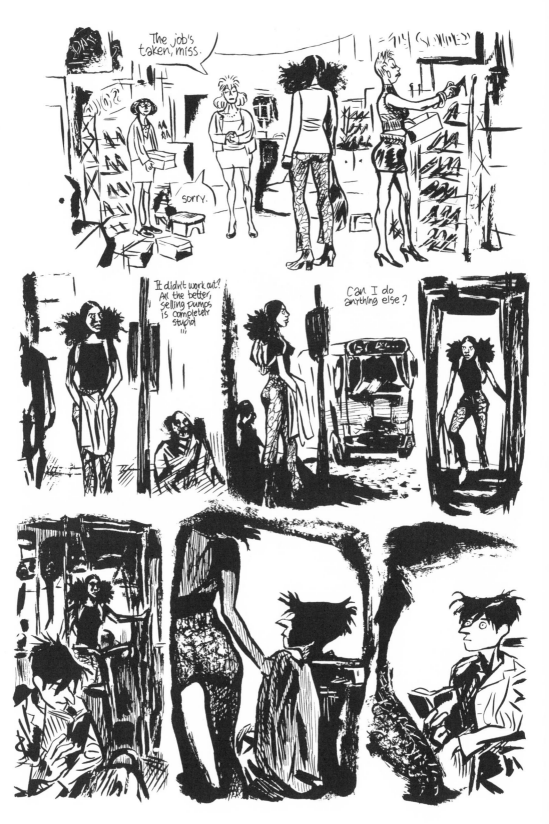

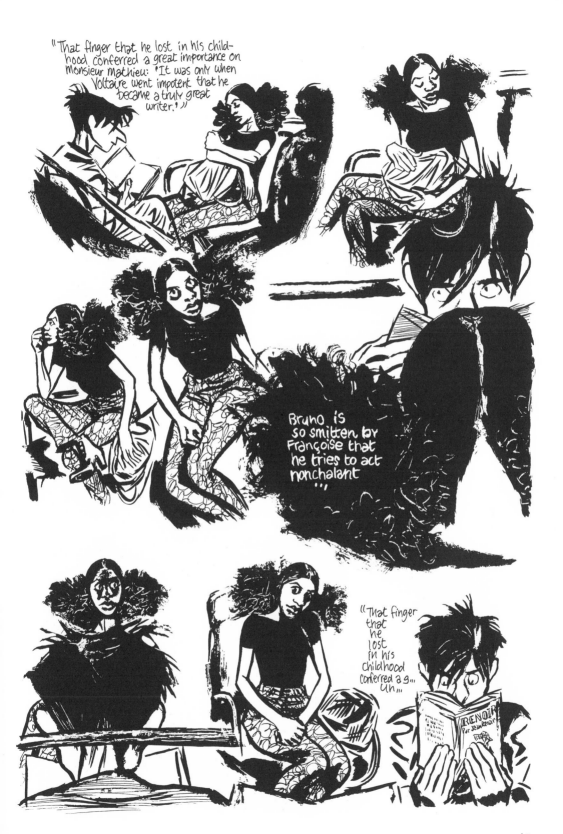

"That finger that he lost in his childhood conferred a great importance on monsieur mathieu: "It was only when Voltaire went impotent that he became a truly great writer.""

Bruno is so smitten by Françoise that he tries to act nonchalant...

"That finger that he lost in his childhood conferred a g... uh...

RENOIR Par Jean Renoir

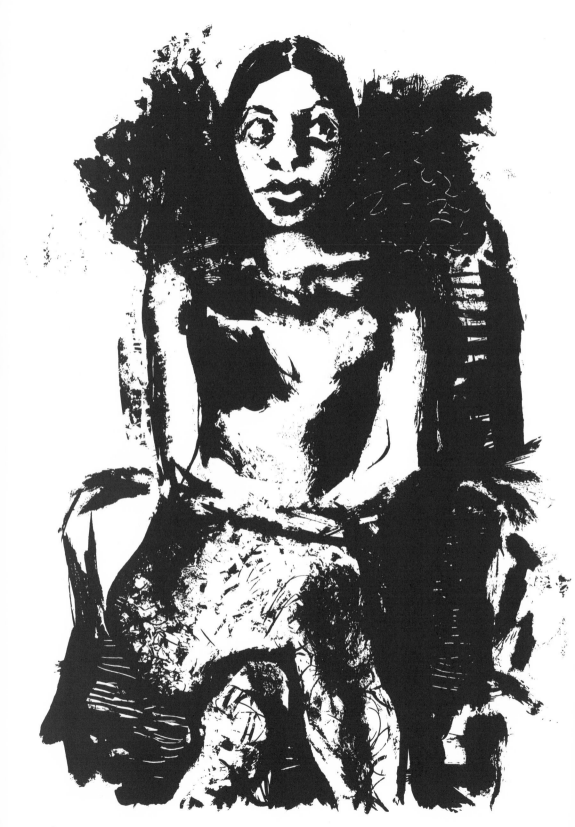

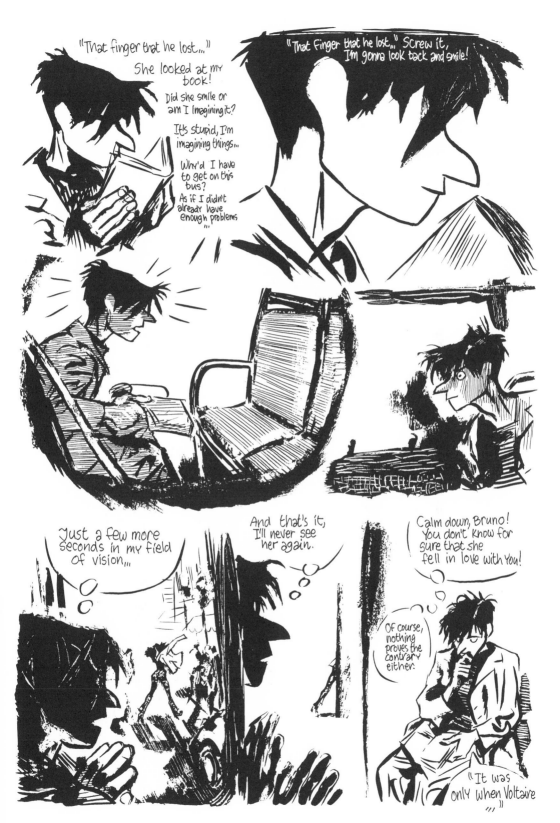

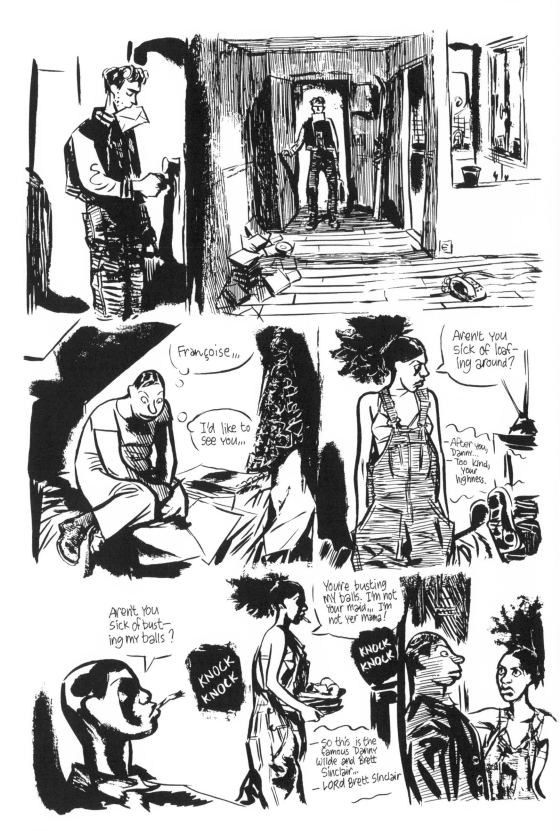

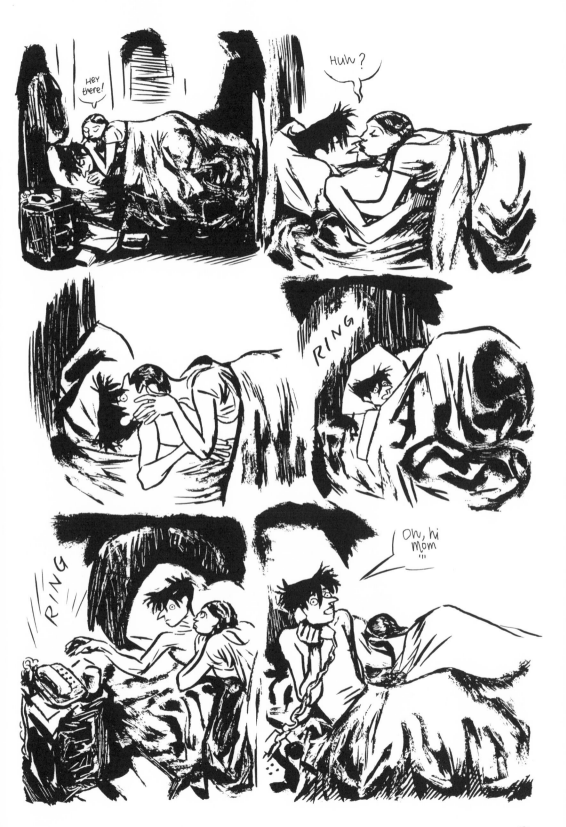

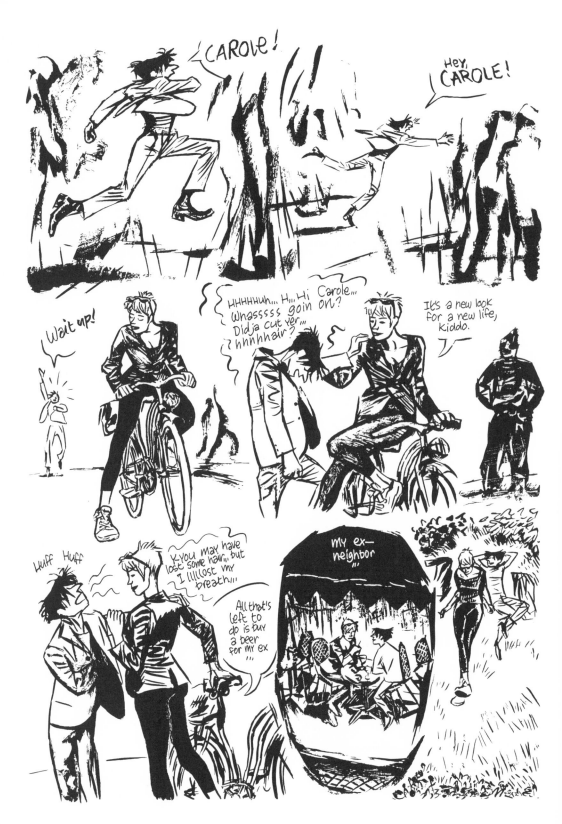

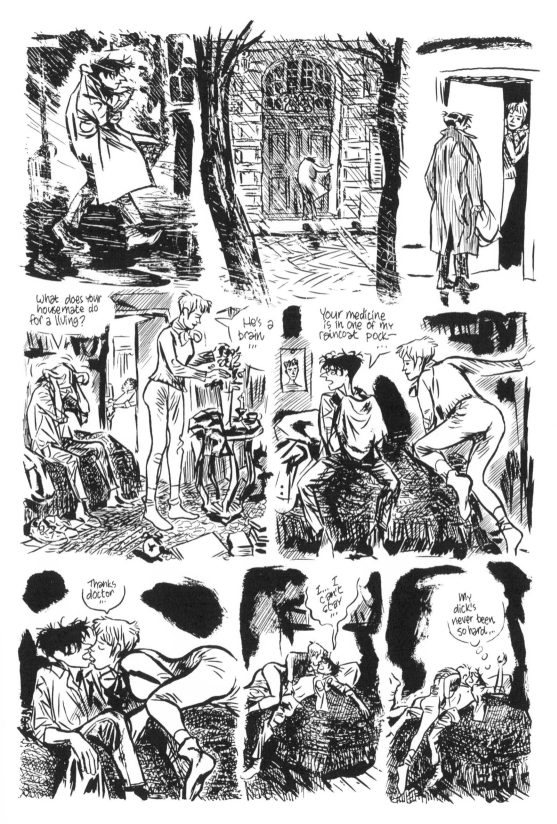

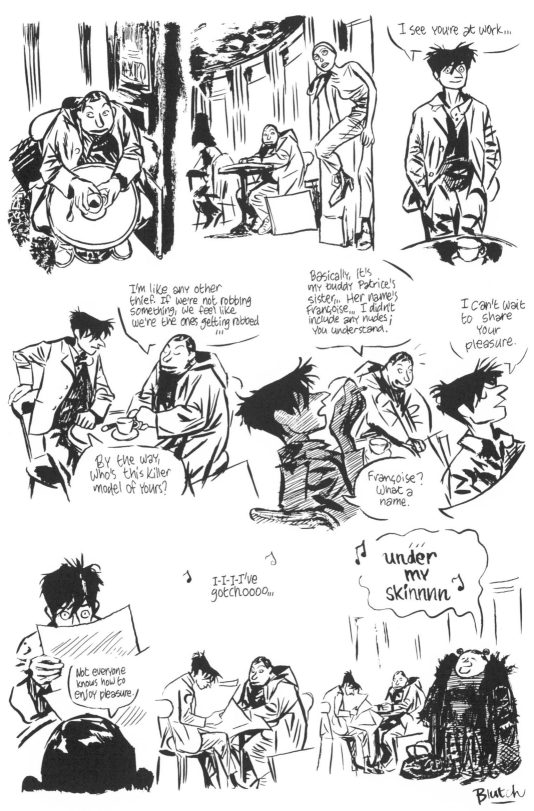

Mitchum
numéro 3
Édité par
Cornélius
100, rue de la
Folie-Méricourt
©Blutch &
Cornélius
Dépôt Légal
4ème trimestre 97
ISBN 2-909990-

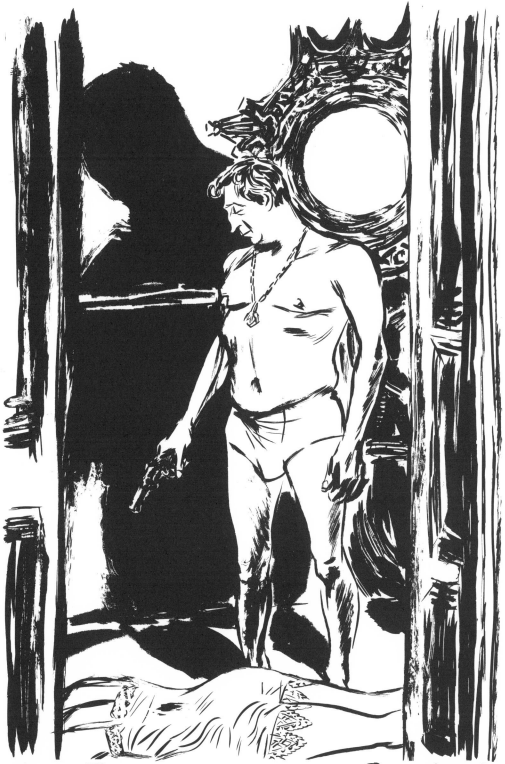

Numéro 3 Éditions Cornélius Collection Paul 45 f

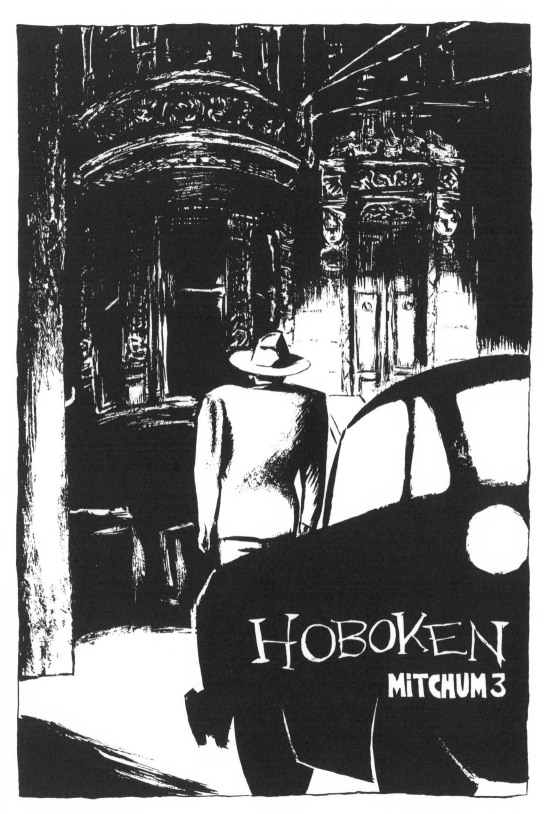

Mitchum #3 is dedicated
to David
Richmond, Gerrit
& John.

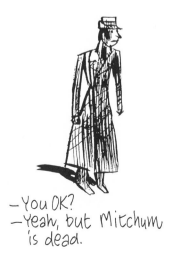

—You OK?
—Yeah, but Mitchum
 is dead.

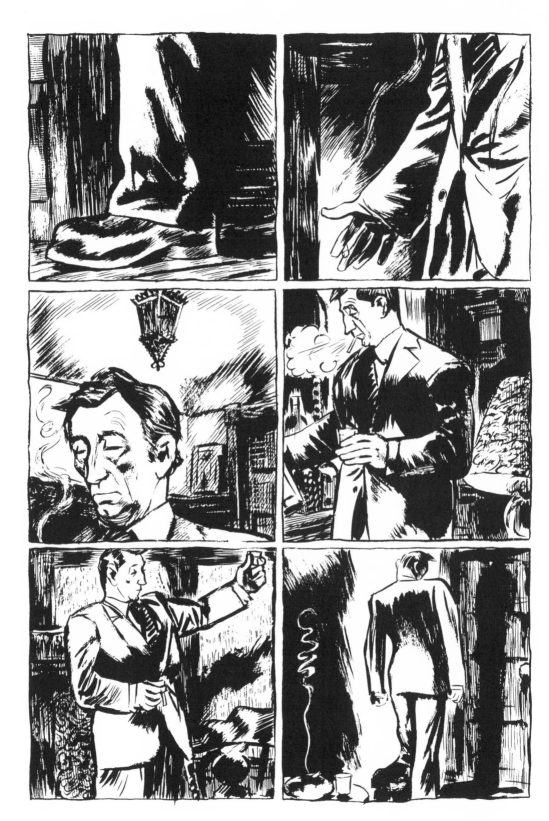

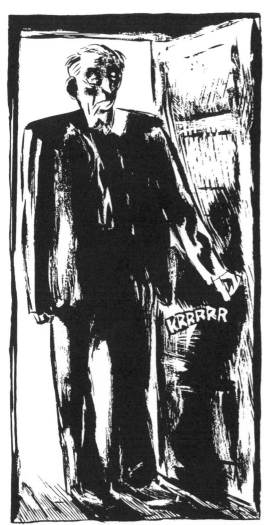

KRRRRR

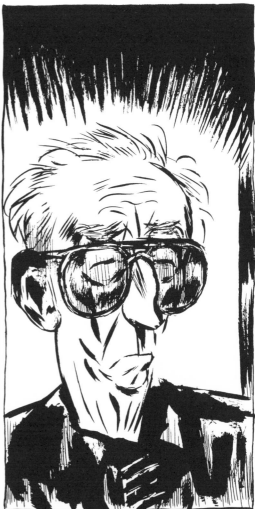

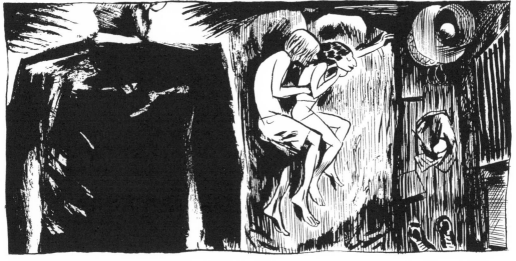

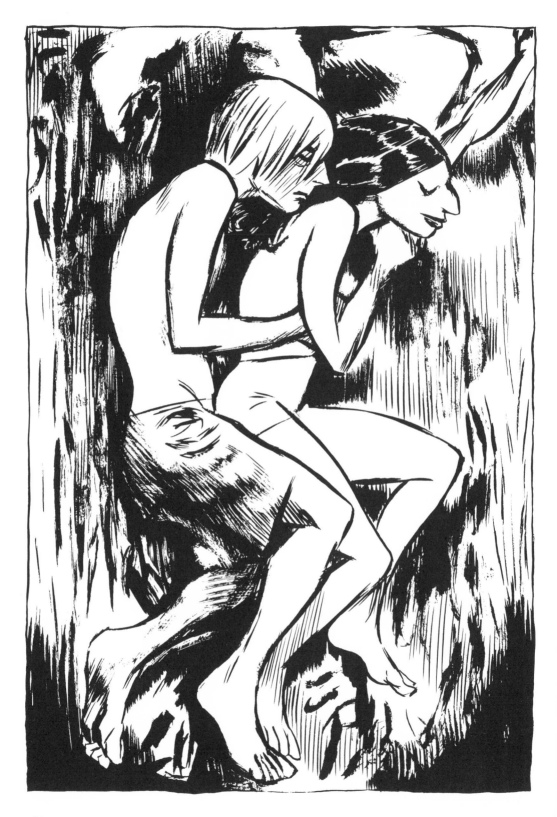

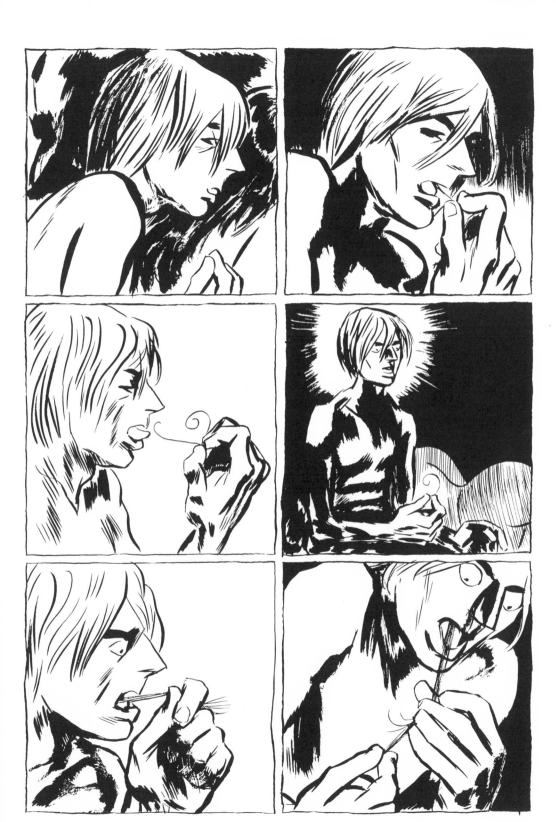

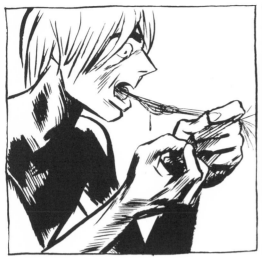

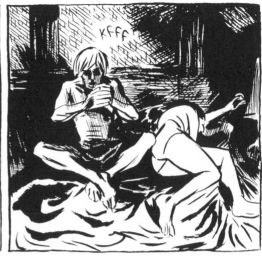

KFFF

RHHHHH

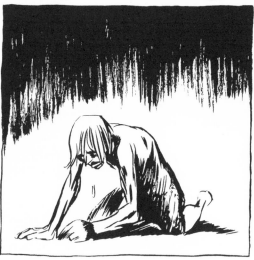
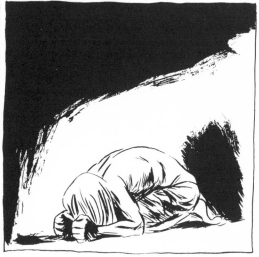

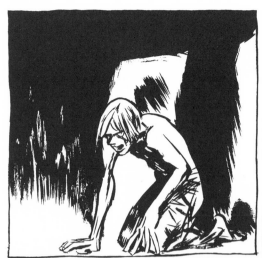
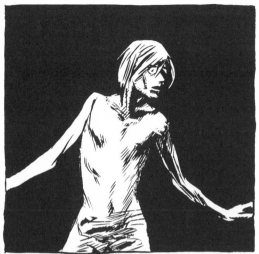
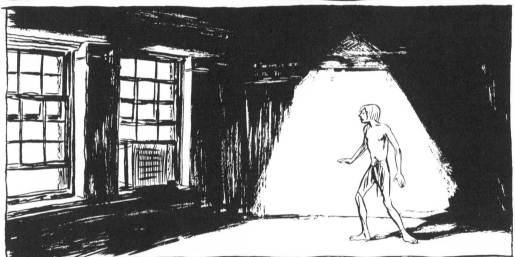
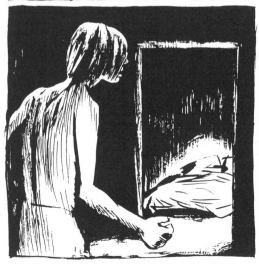
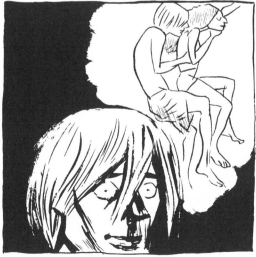

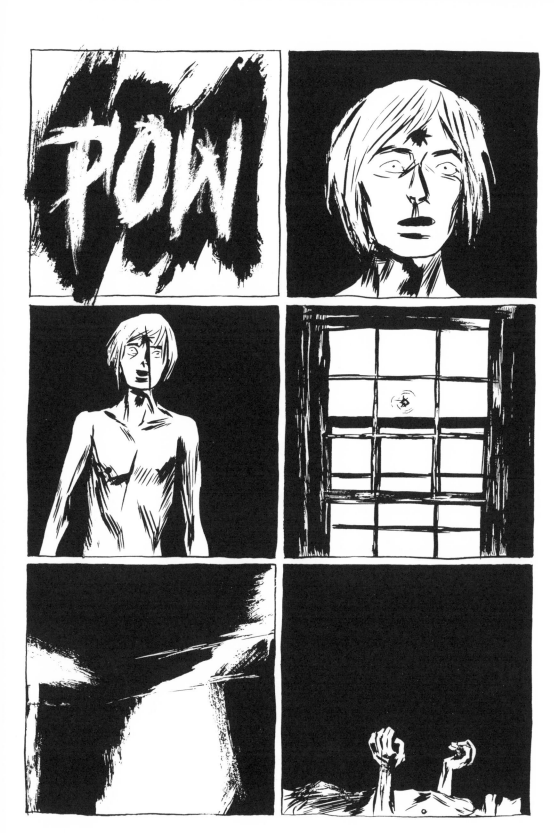

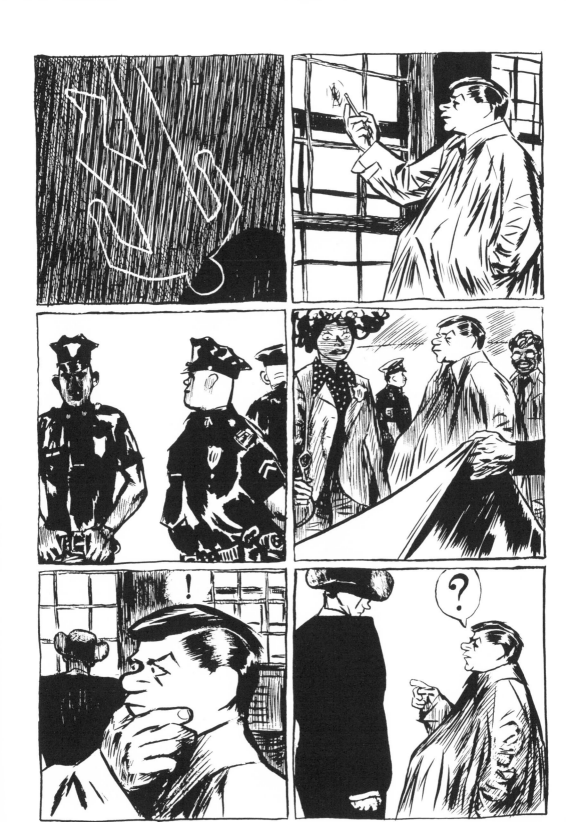

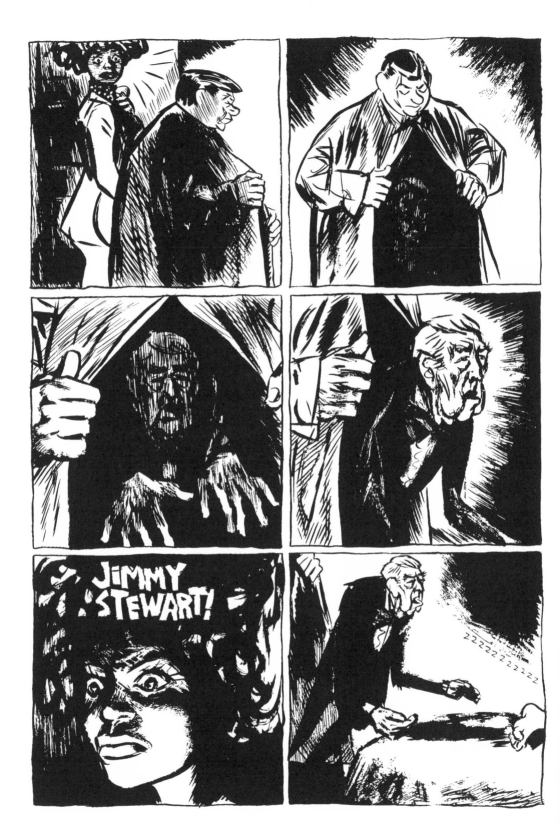

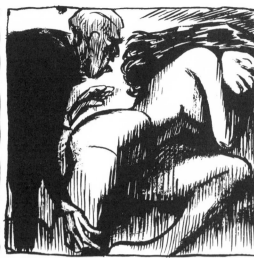
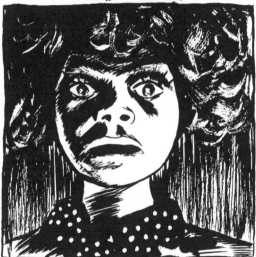
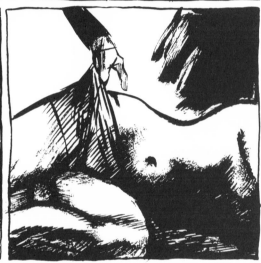
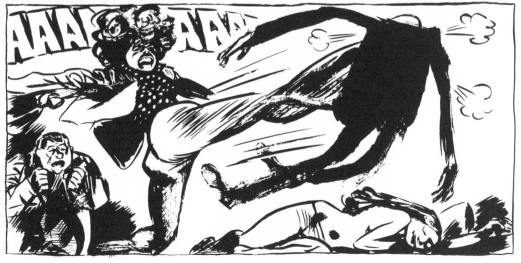

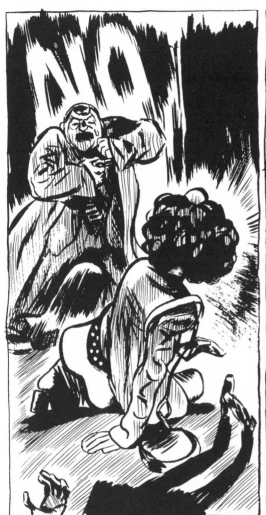

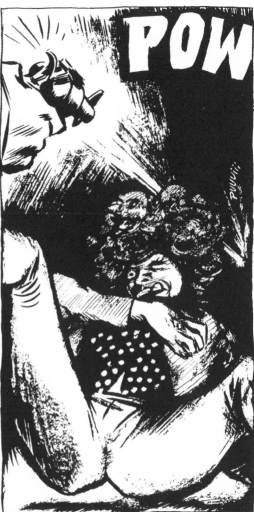

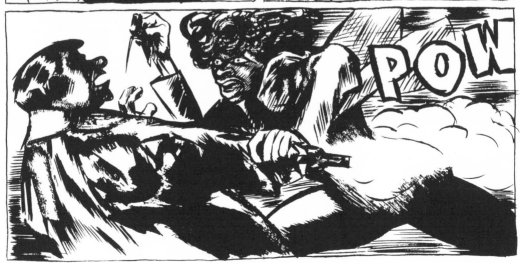

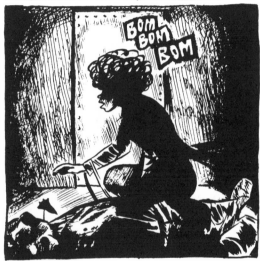

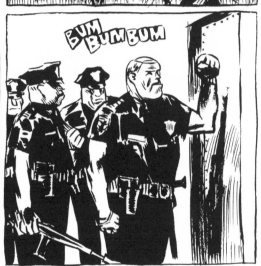

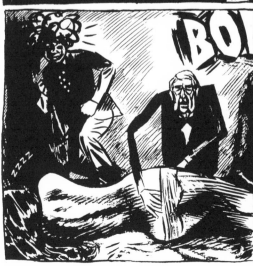

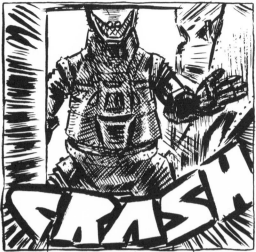
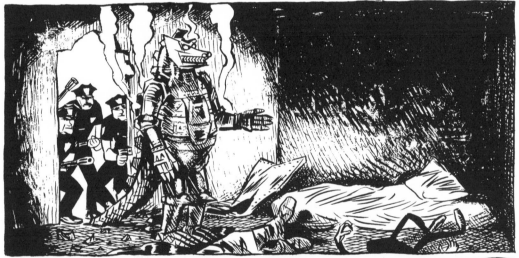
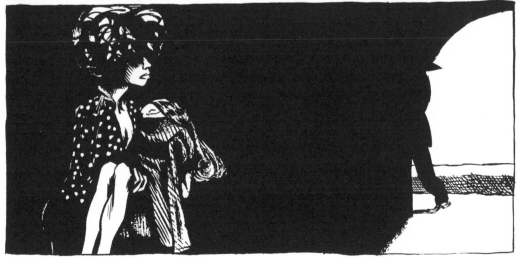

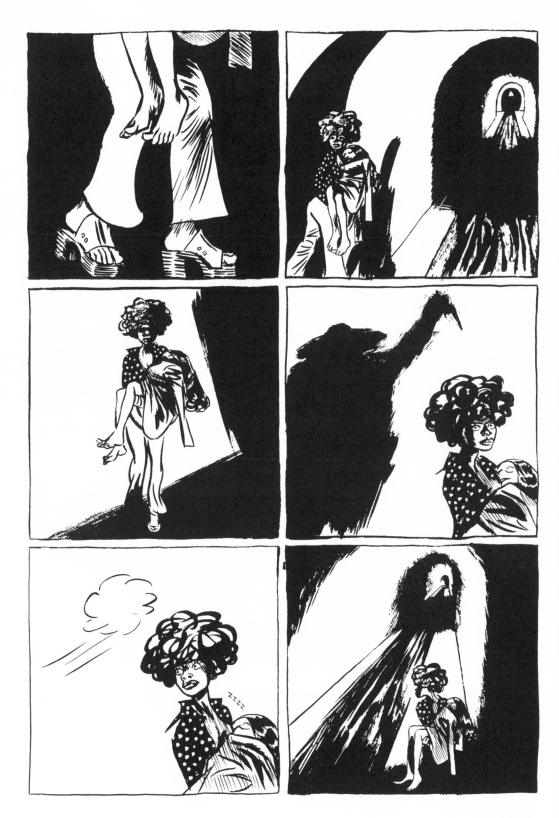

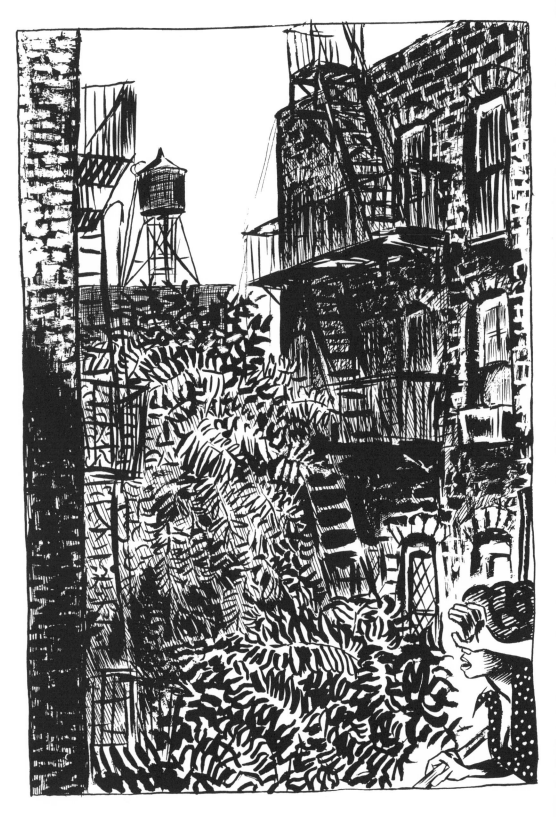

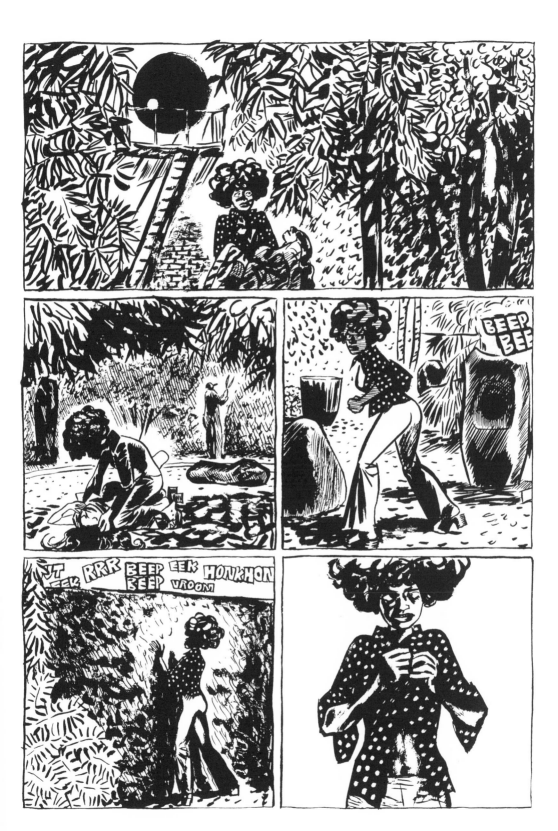

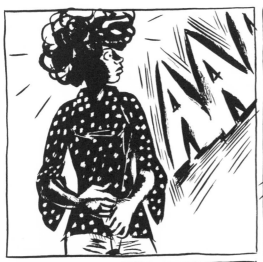
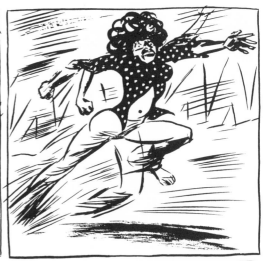
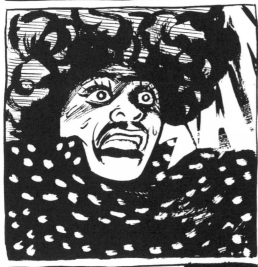

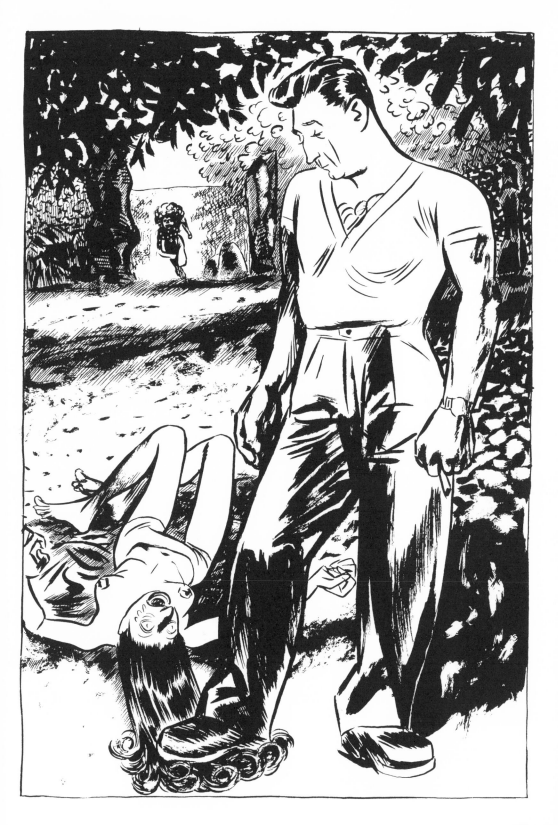

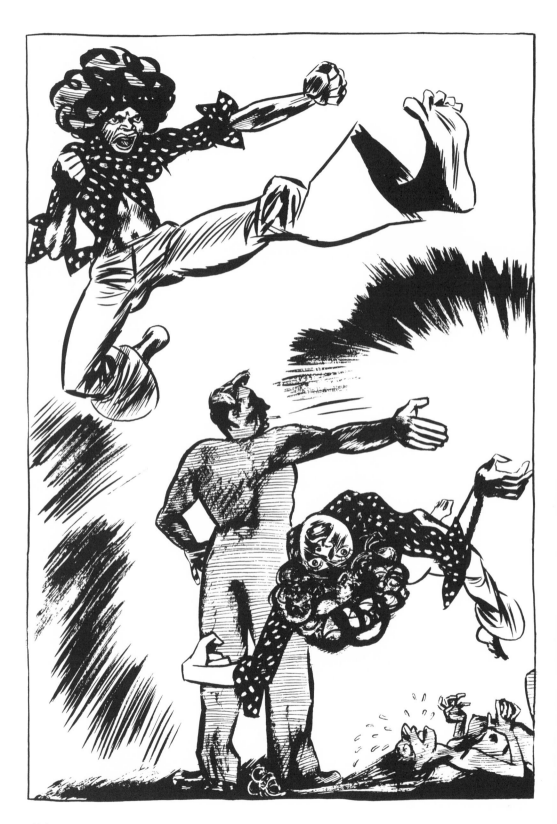

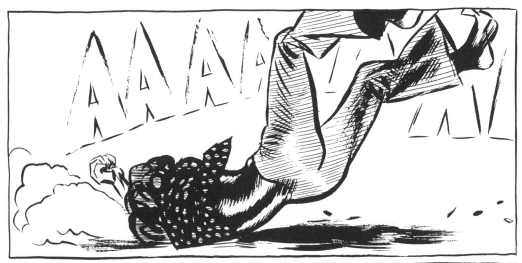

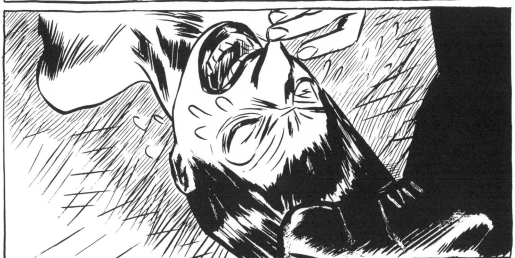

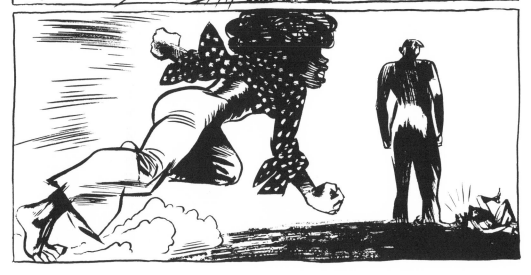

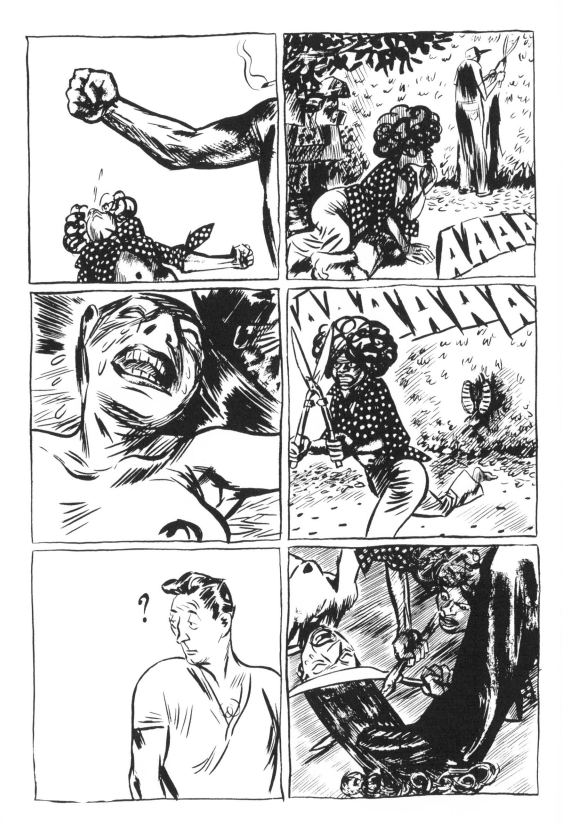

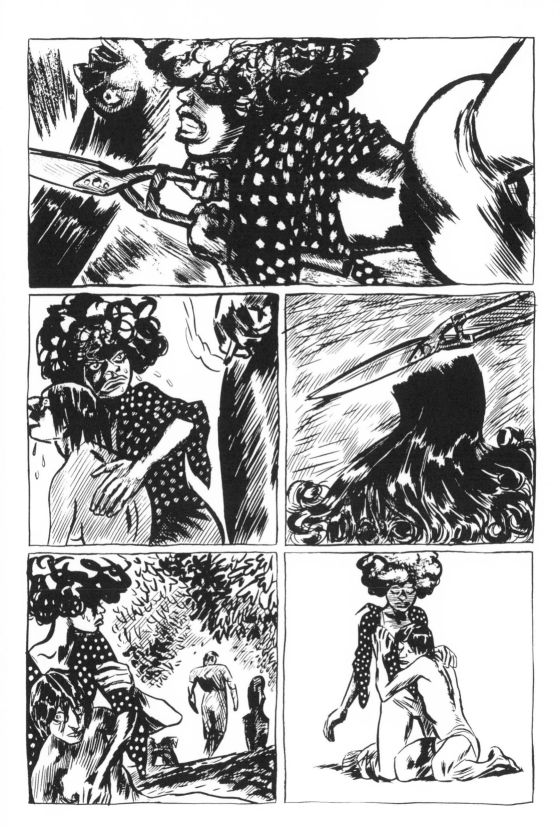

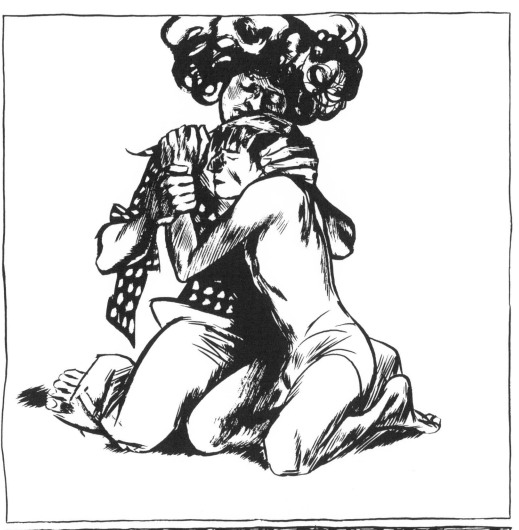

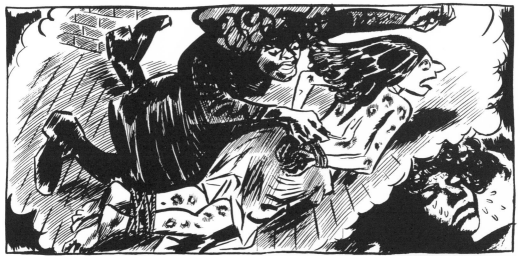

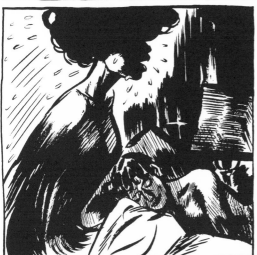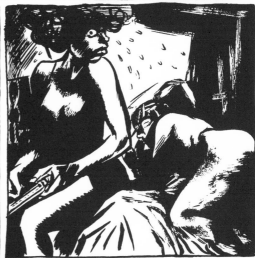

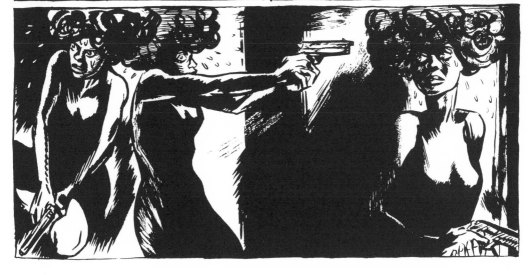

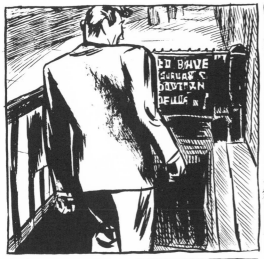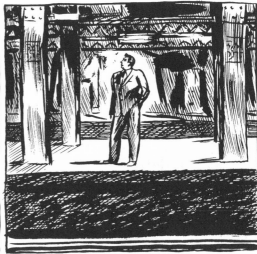

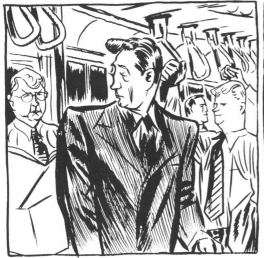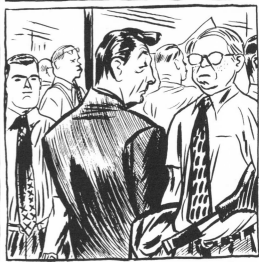

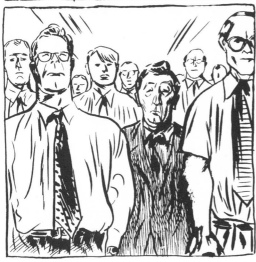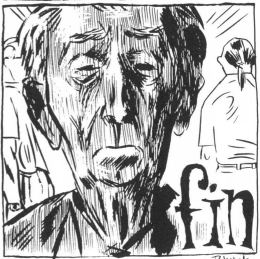

fin

BLUTCH

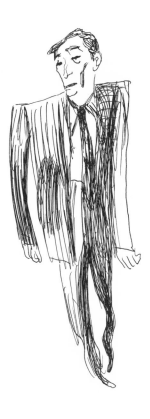

Mitchum
numéro 4
Édité par
Cornélius
100, rue de la
Folie-Méricourt
© Blutch &
Cornélius
Dépôt légal
2ème trimestre 98
ISBN 2-909990-29-X

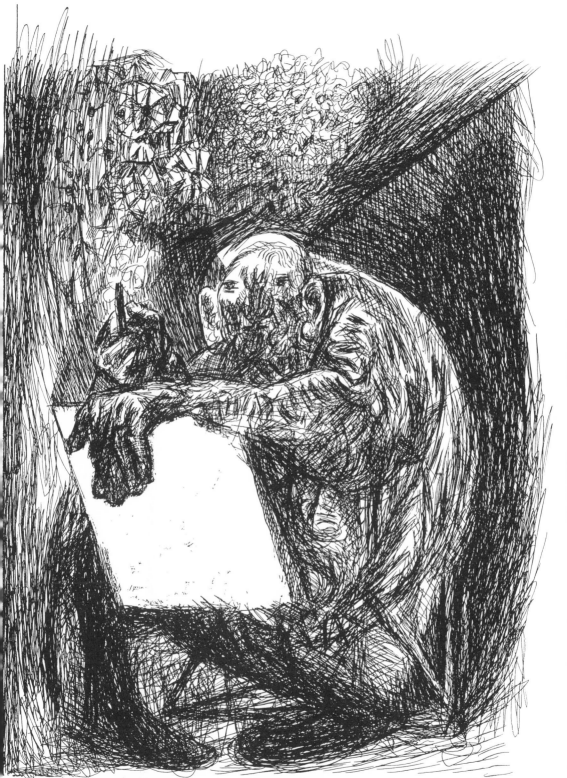

Numéro 4 Éditions Cornélius collection Paul 45f

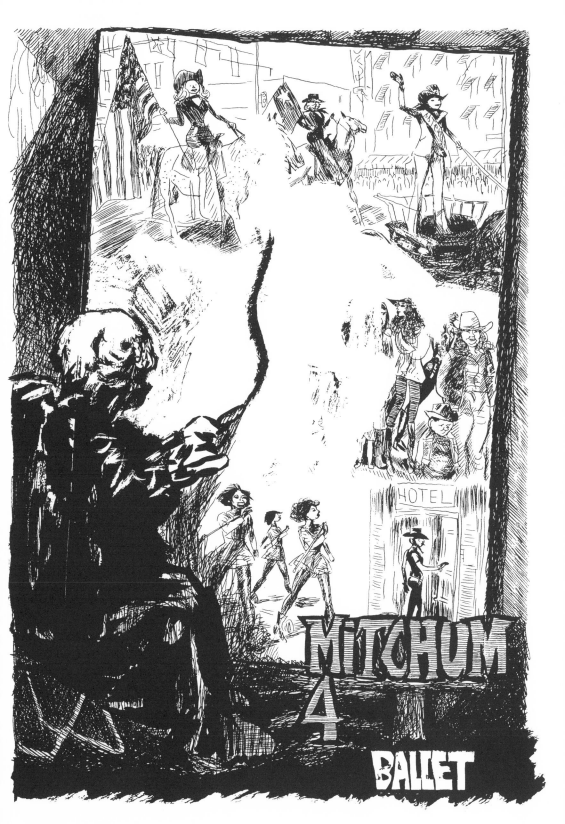

Come fly with me
Let's fly let's fly away

FRANK SINATRA
"Come Fly With Me"
(Cahn / Van Heusen)

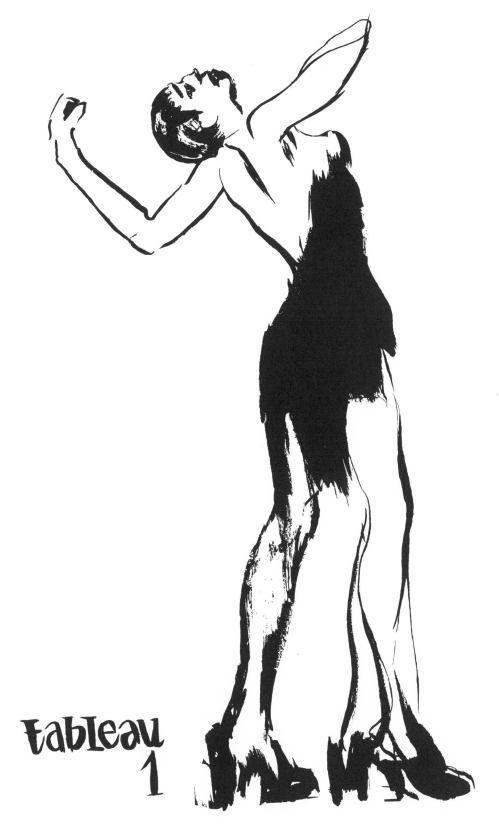

tableau
1

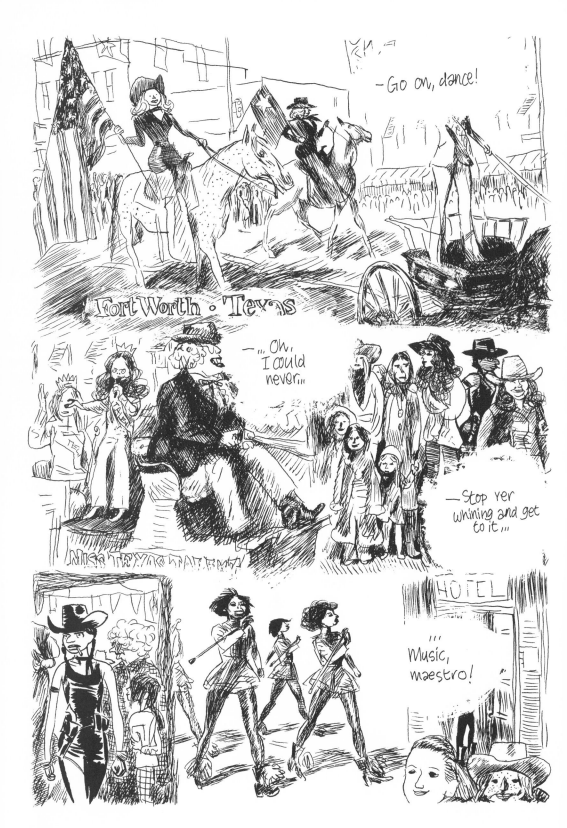

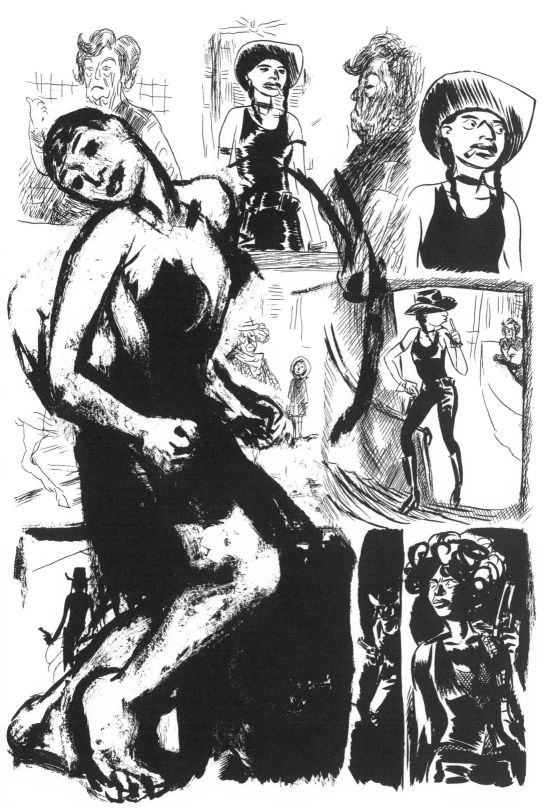

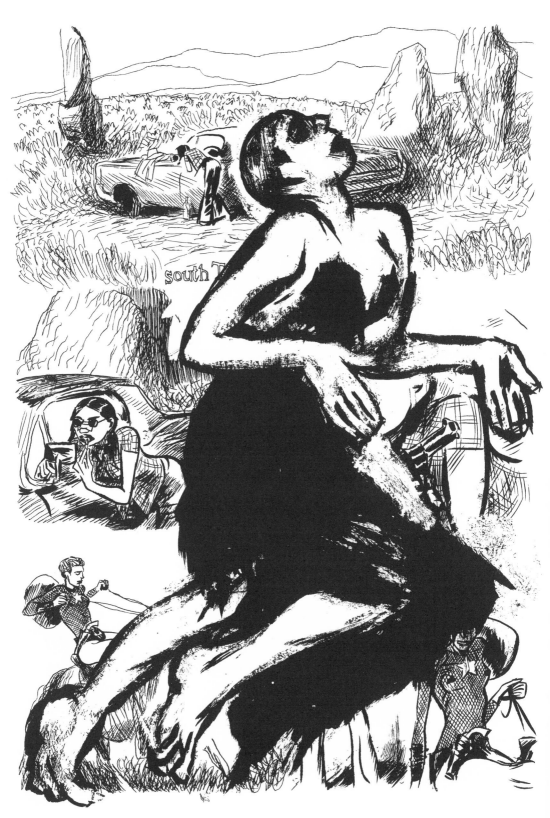

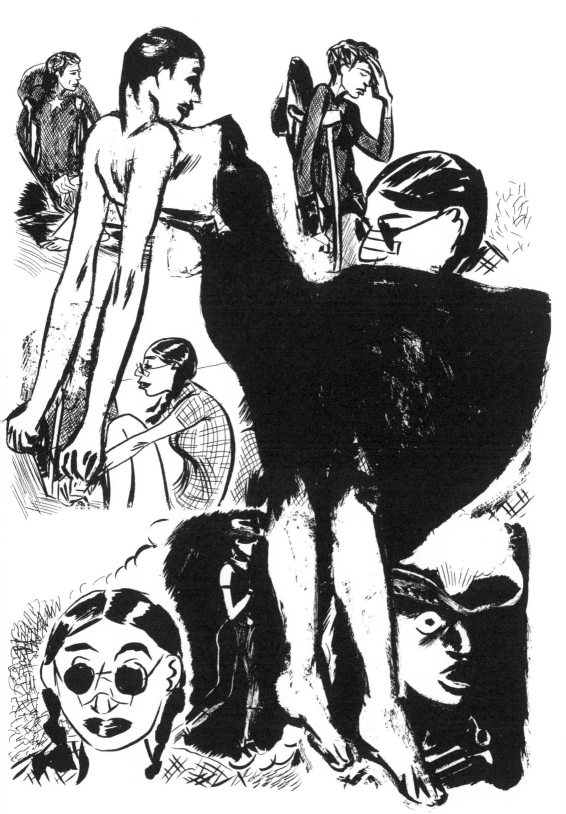

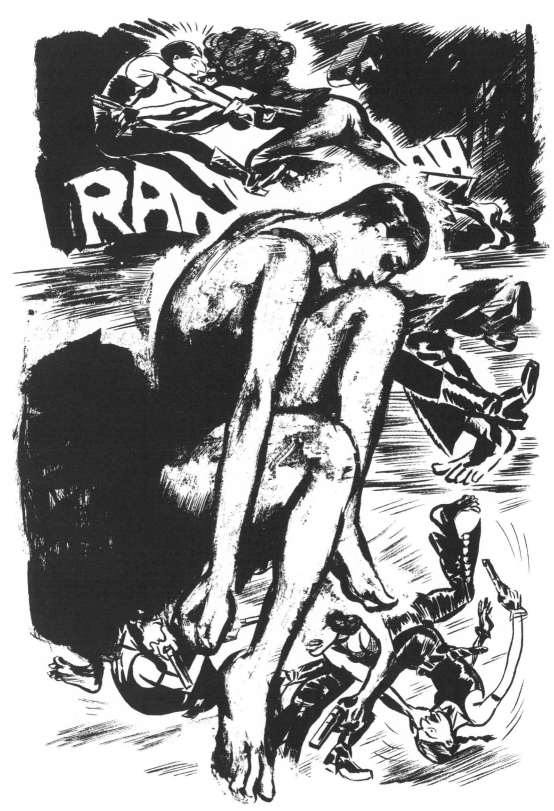

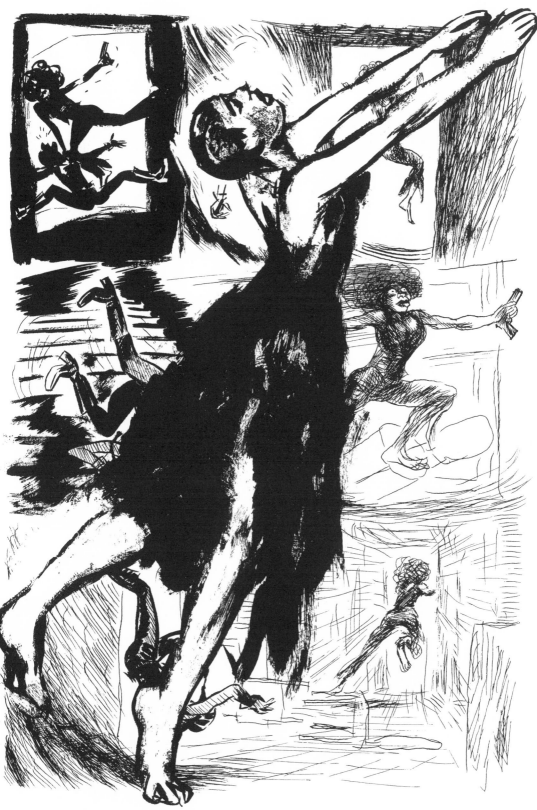

123

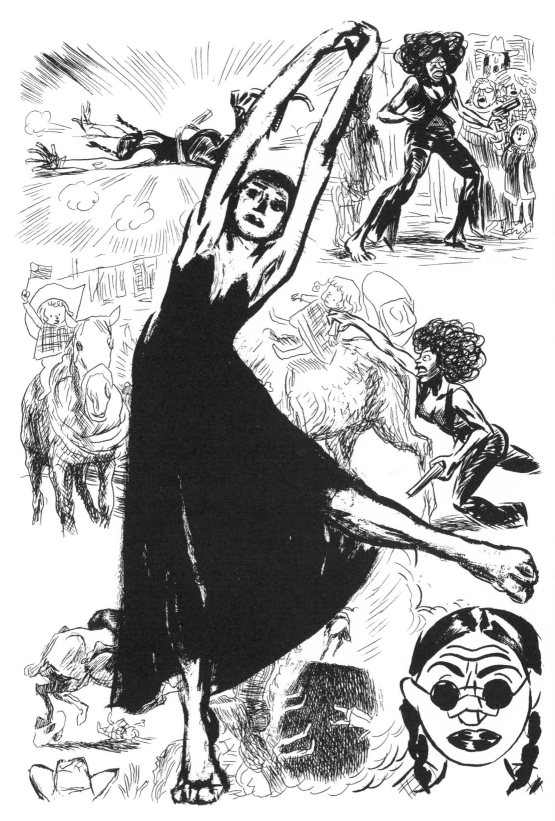

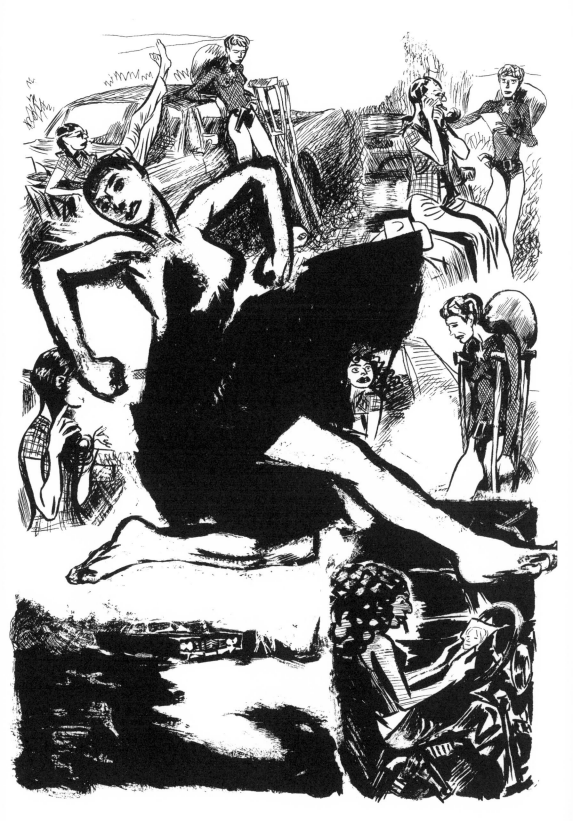

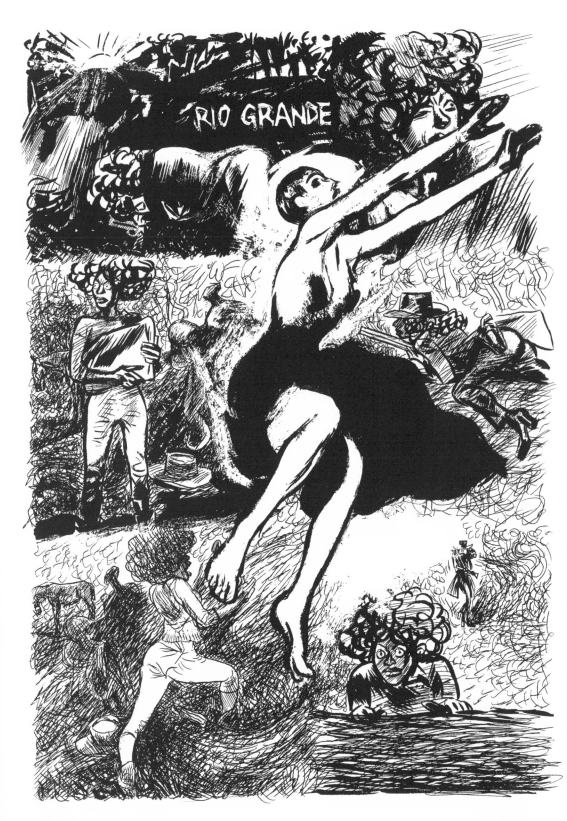

126

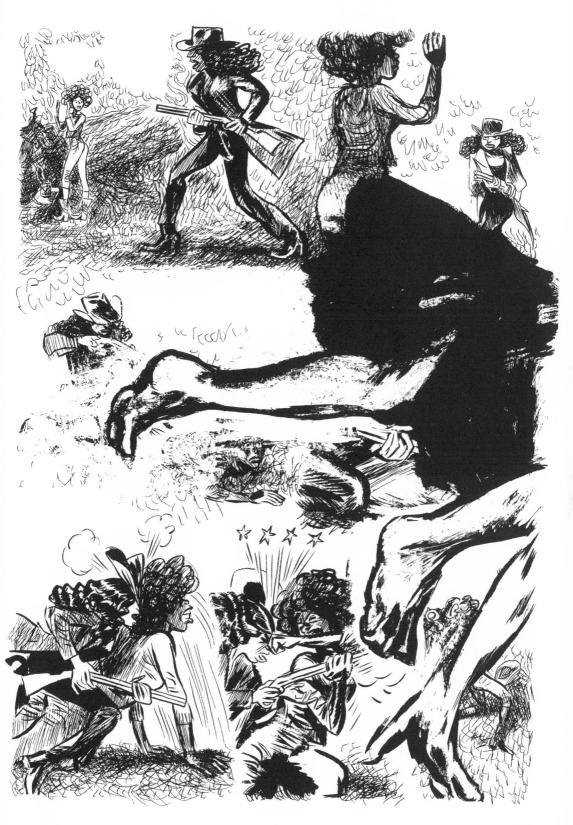

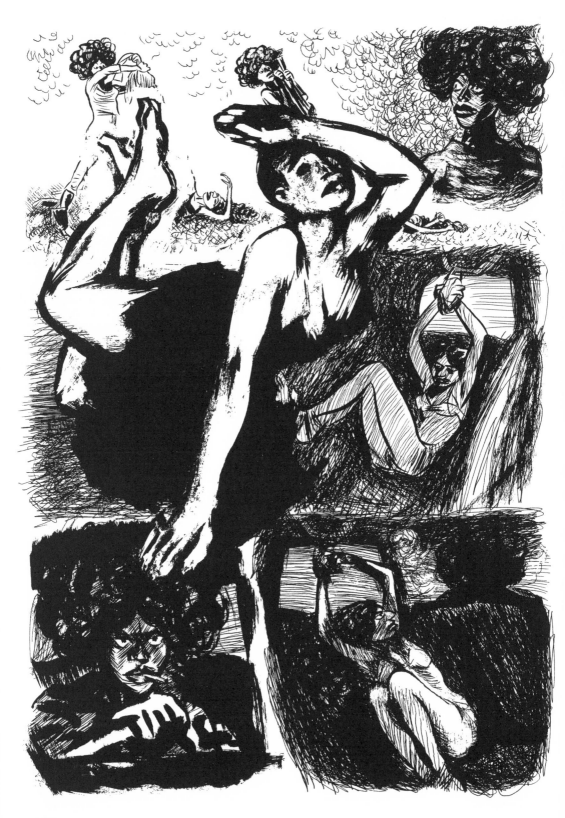

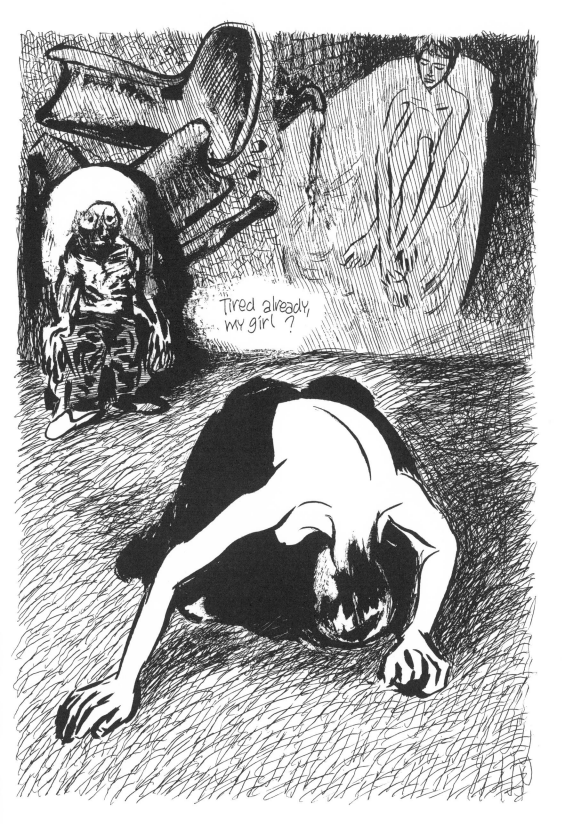

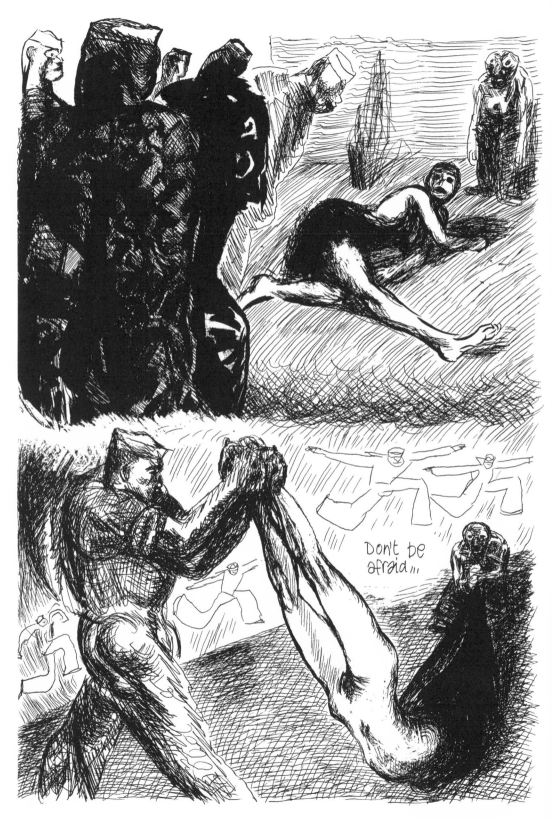

130

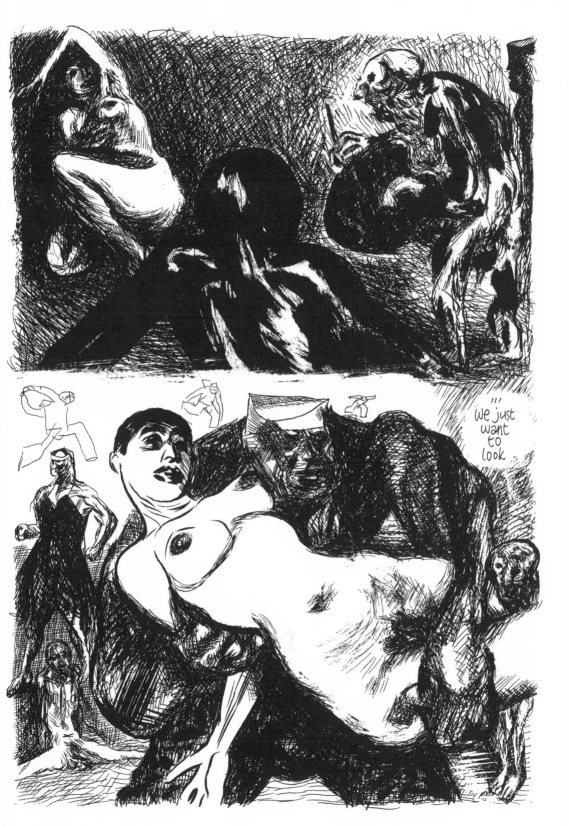

"we just
want
to
look..

131

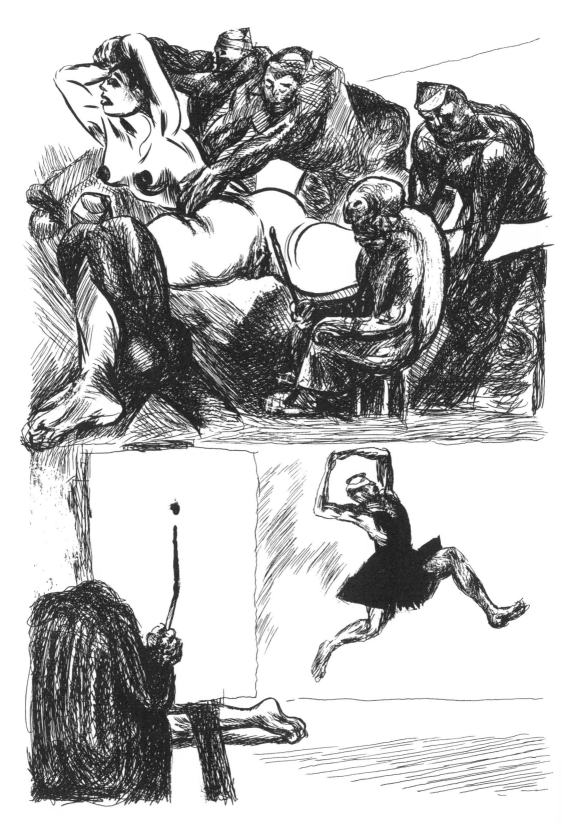

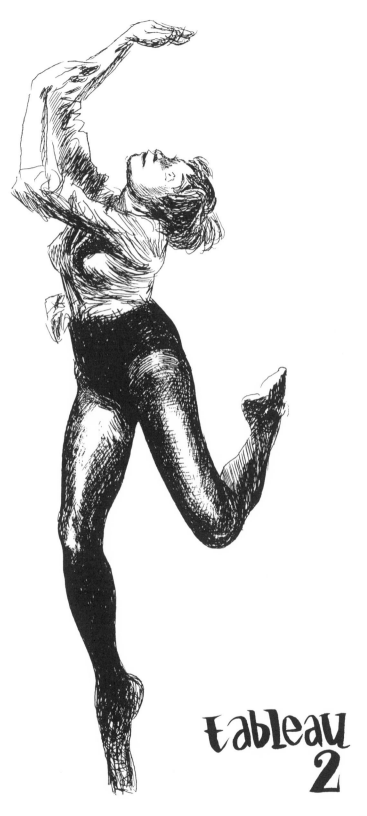

tableau
2

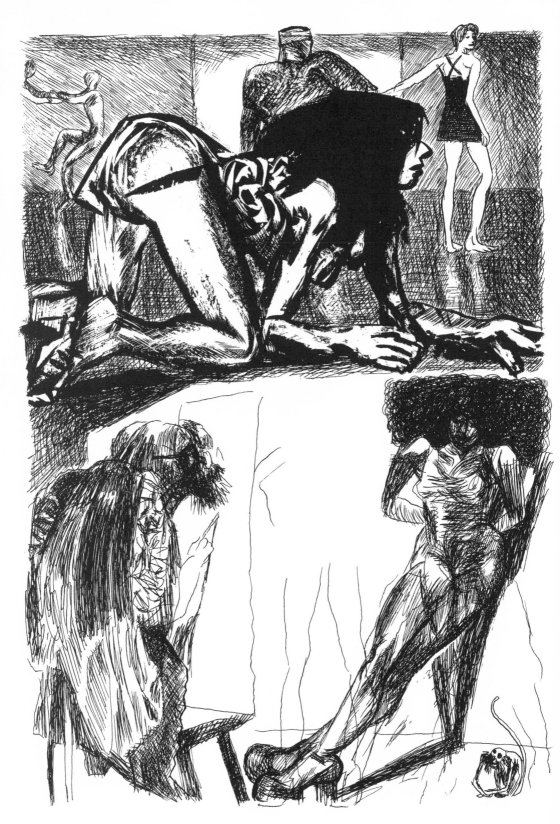

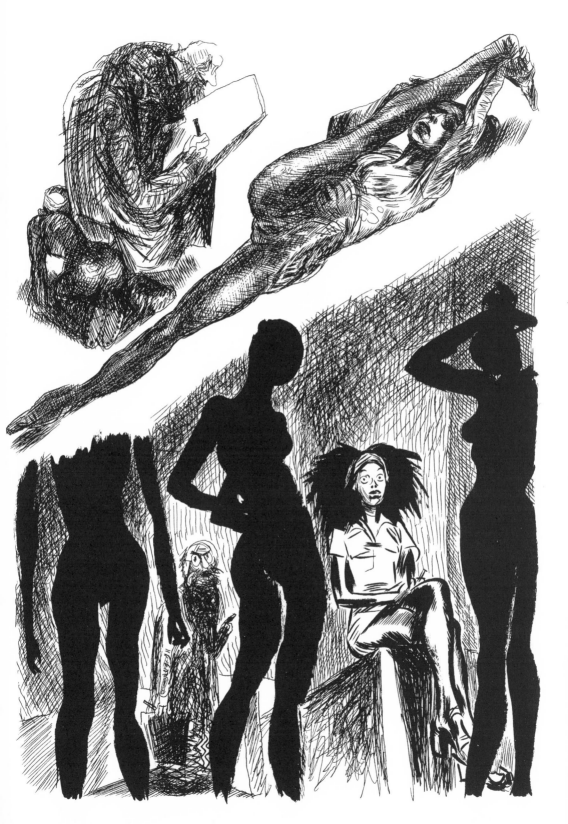

135

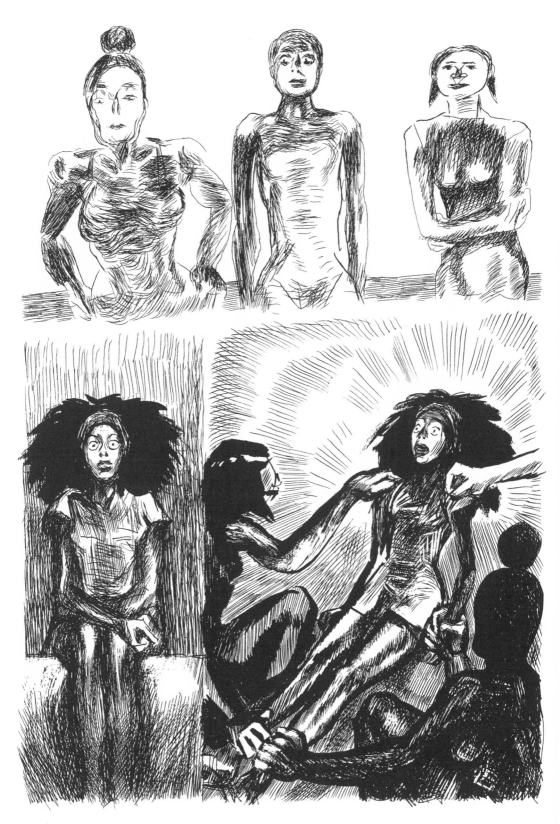

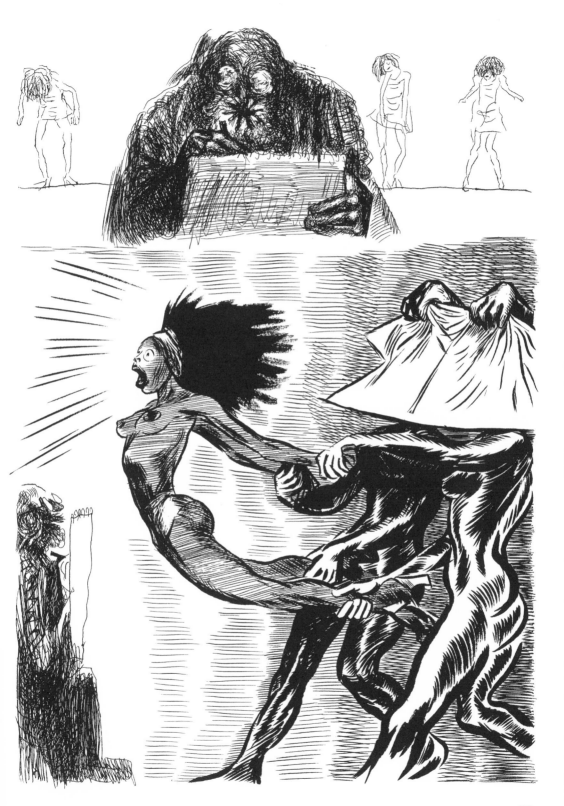

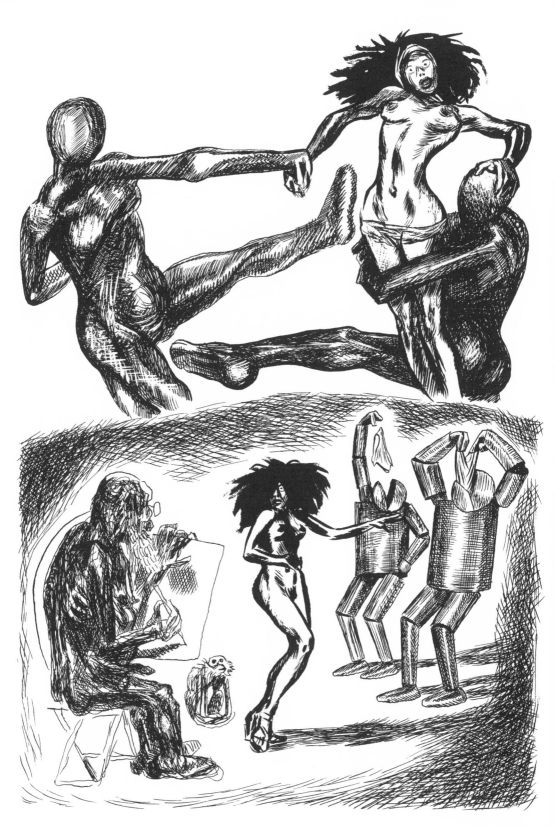

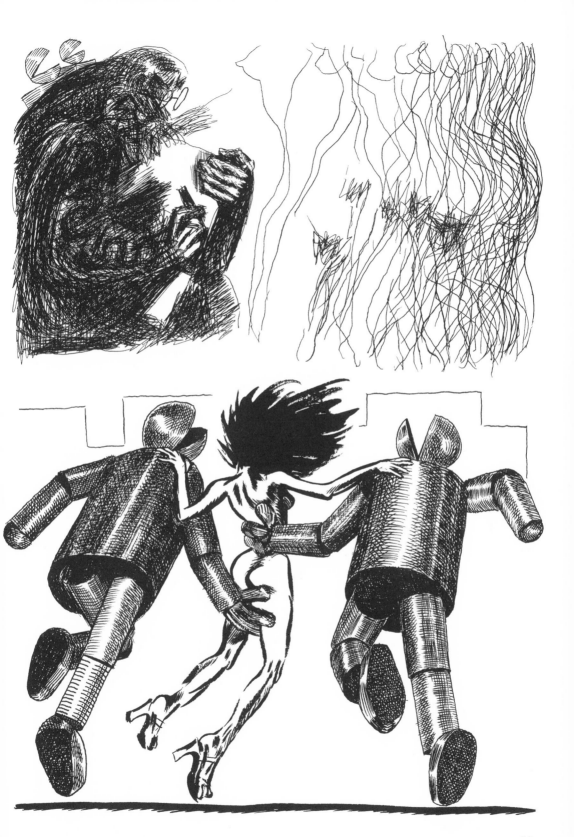

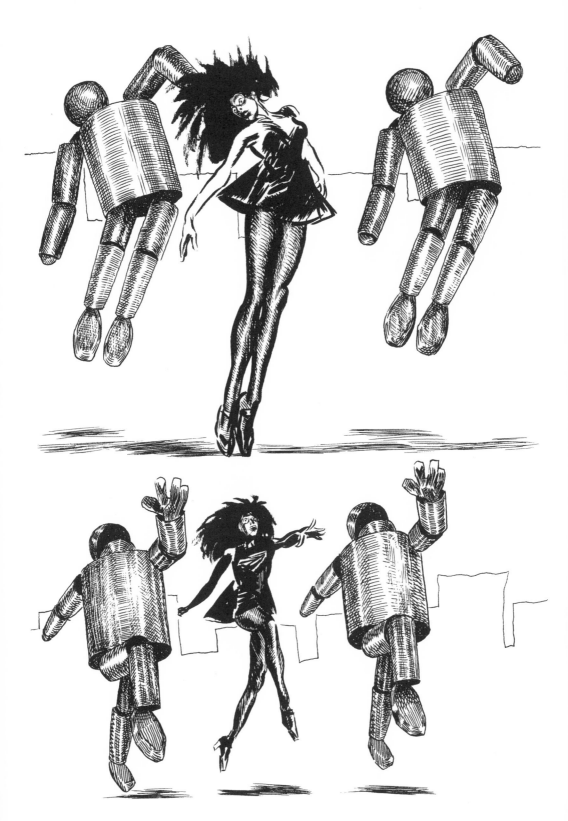

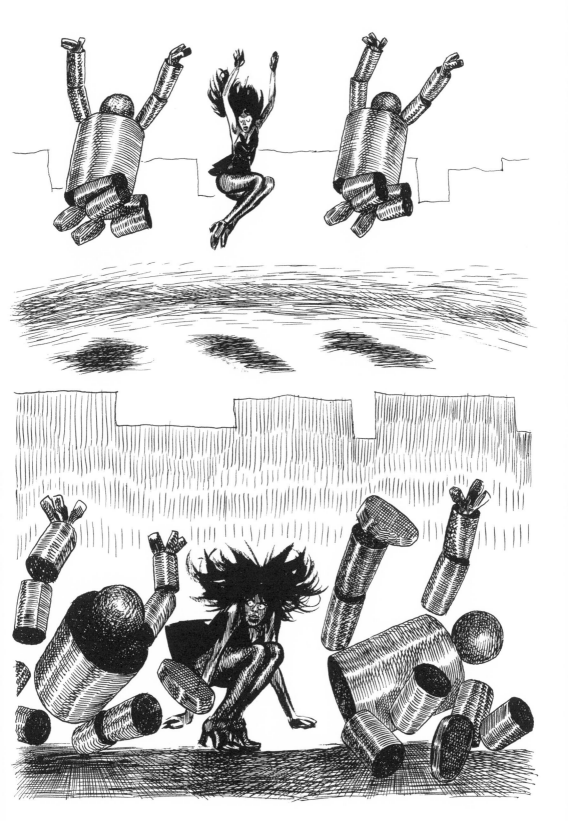

141

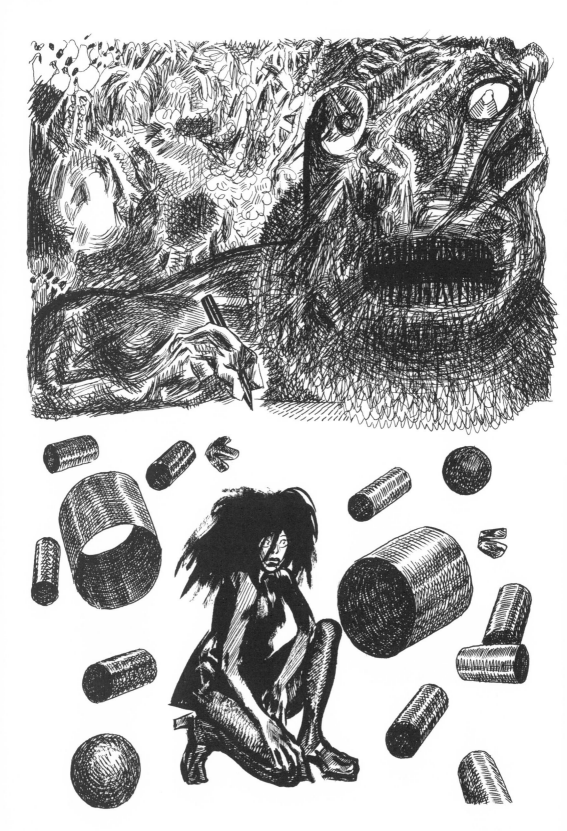

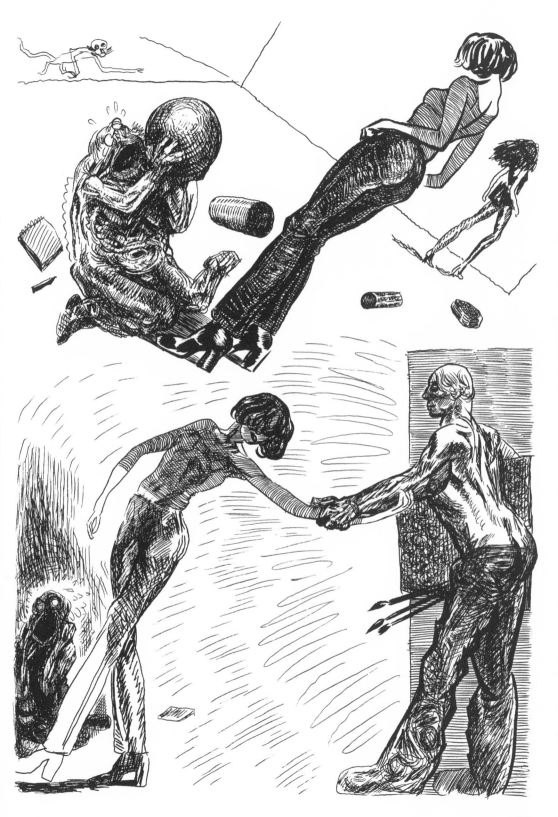

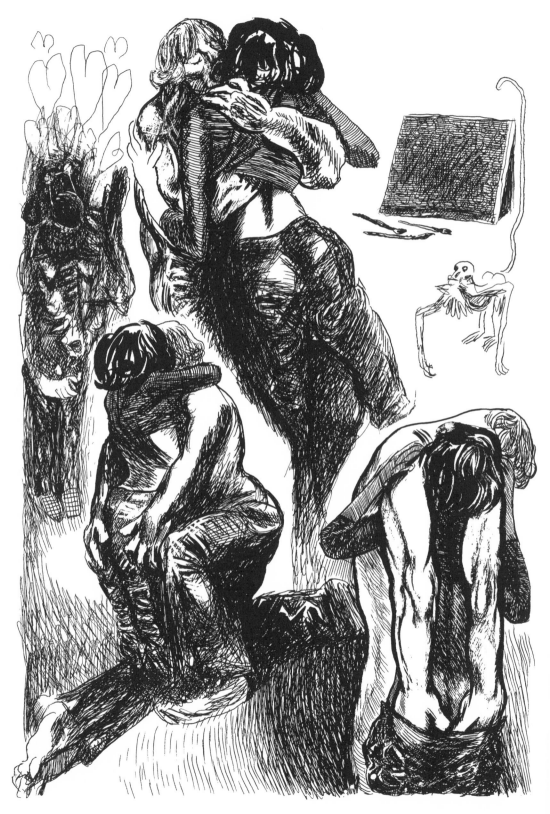

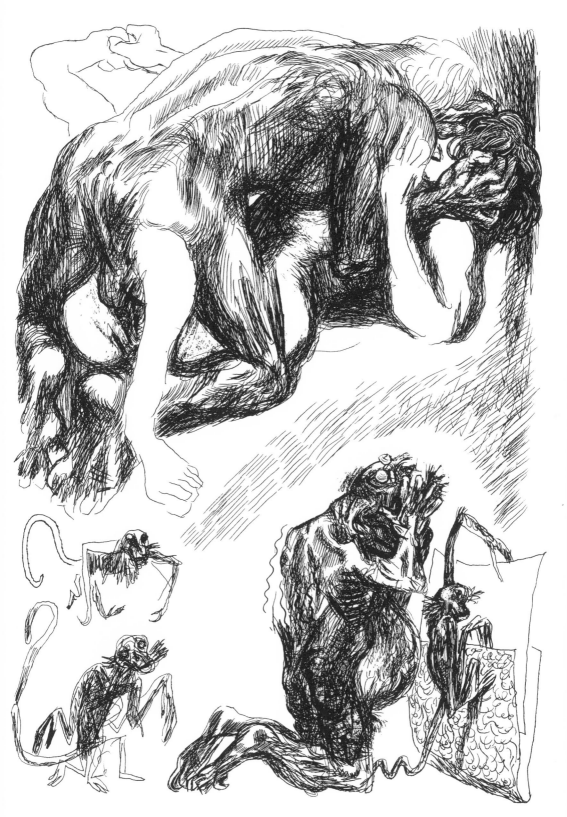

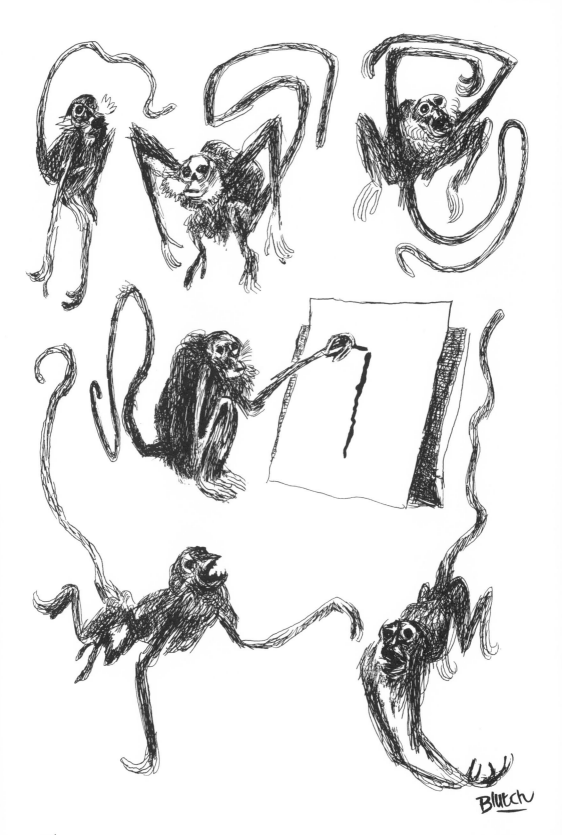

Mitchum
numéro 5
Édité par
Cornélius
100, rue de la
Folie-Méricourt
© Blutch &
Cornélius
Dépôt légal
1er trimestre 99
ISBN 2-909990-42-7

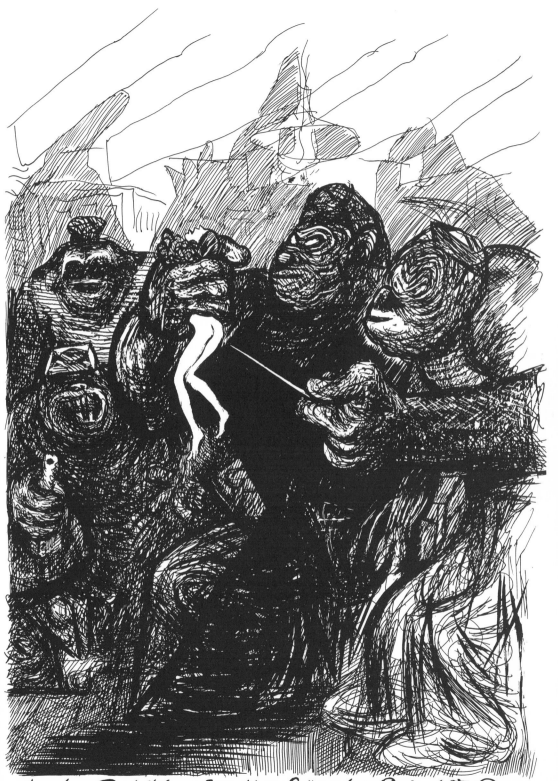

Numéro 5 Éditions Cornélius Collection Paul 45 FF

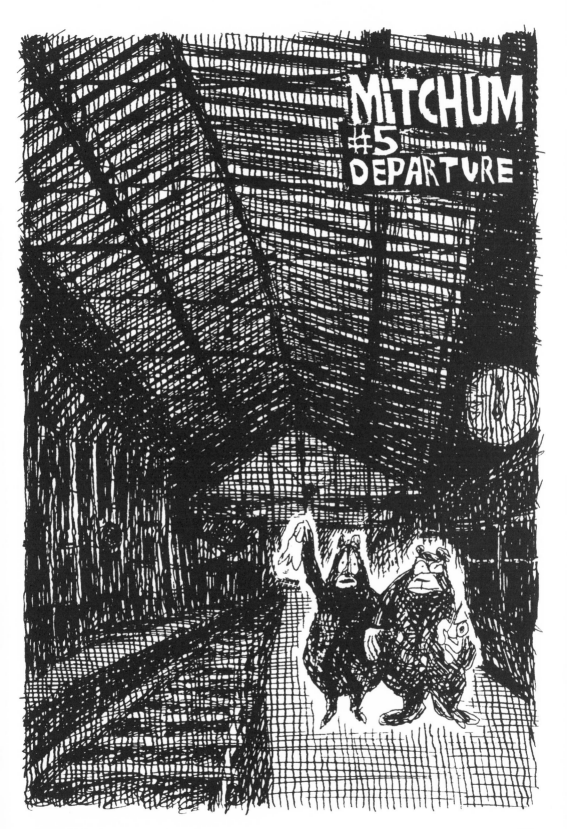

She stepped up to the
tree and took one of its
pears in her mouth, just
one pear that she ate to ease
her hunger, and nothing more.
The Brothers Grimm
"The Girl
without Hands"

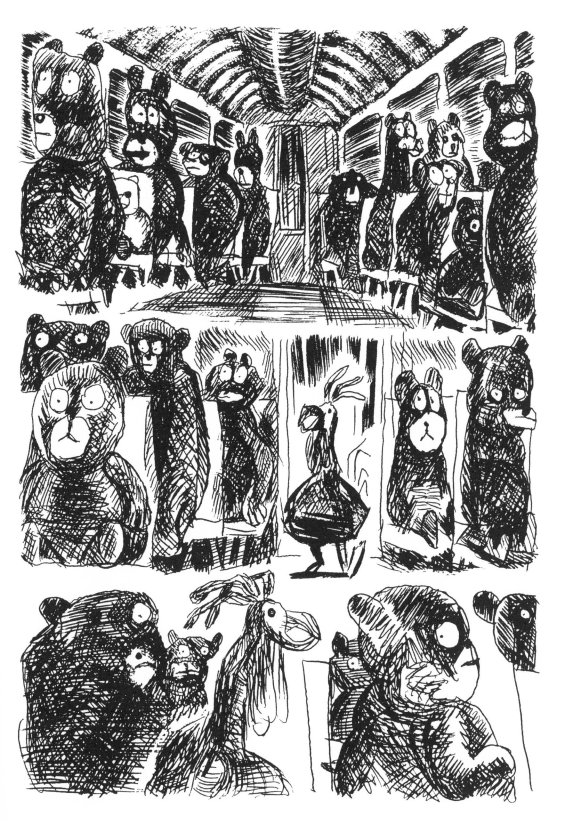

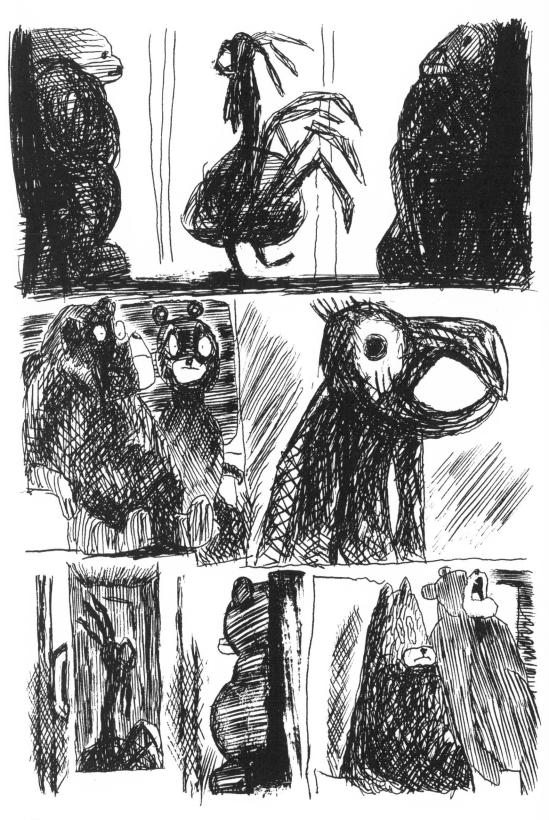

154

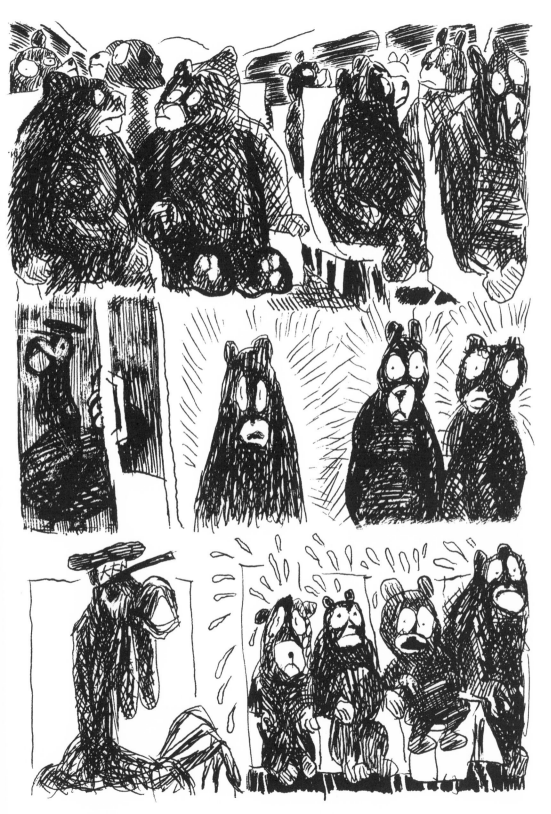

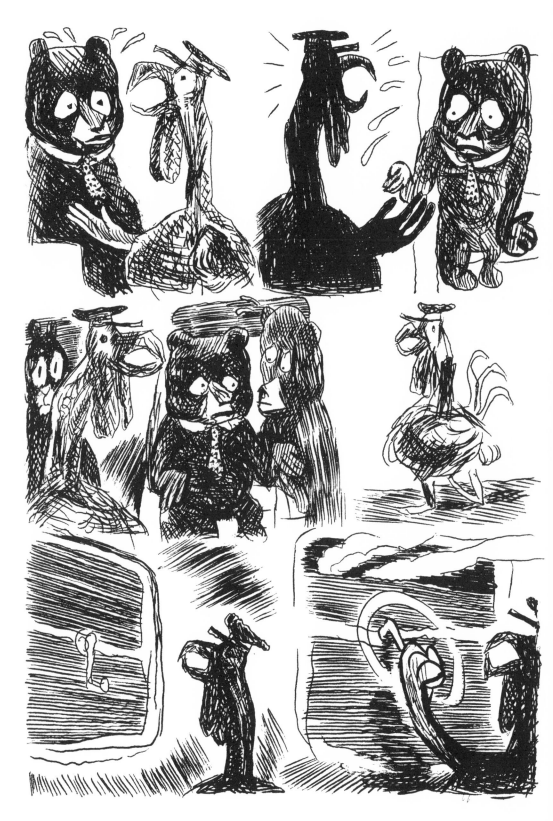

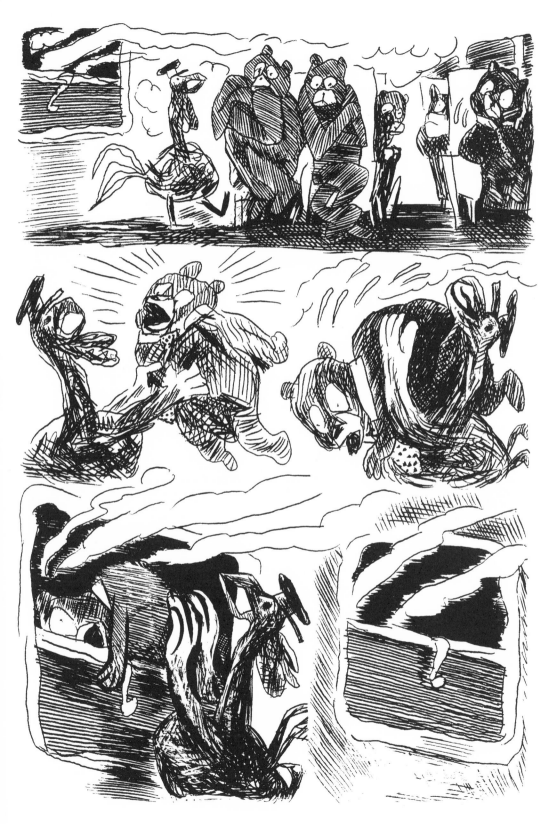

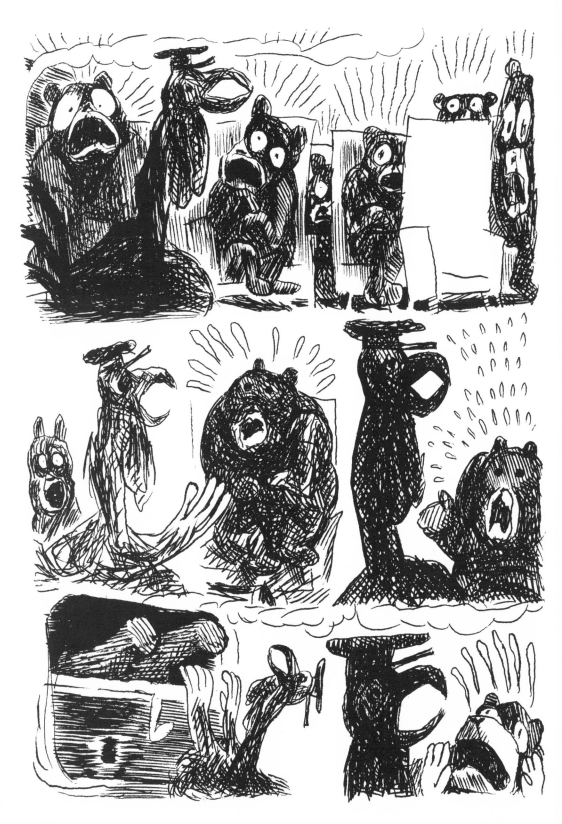

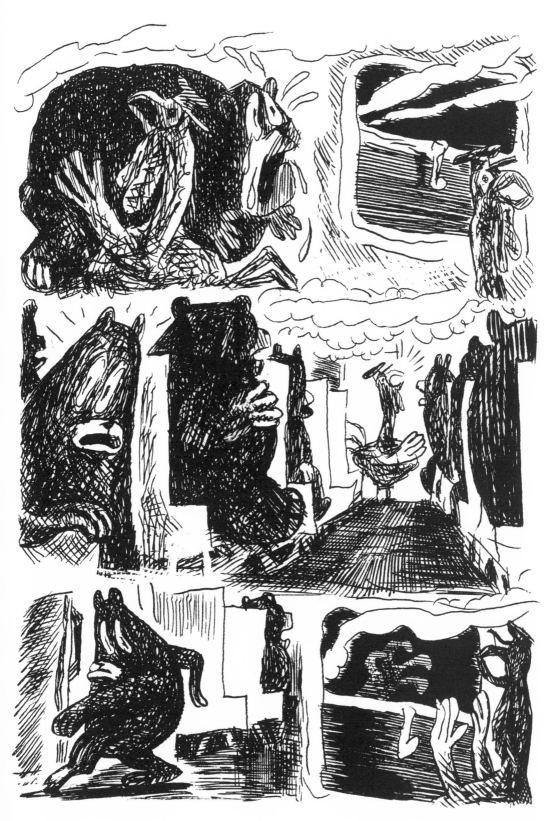

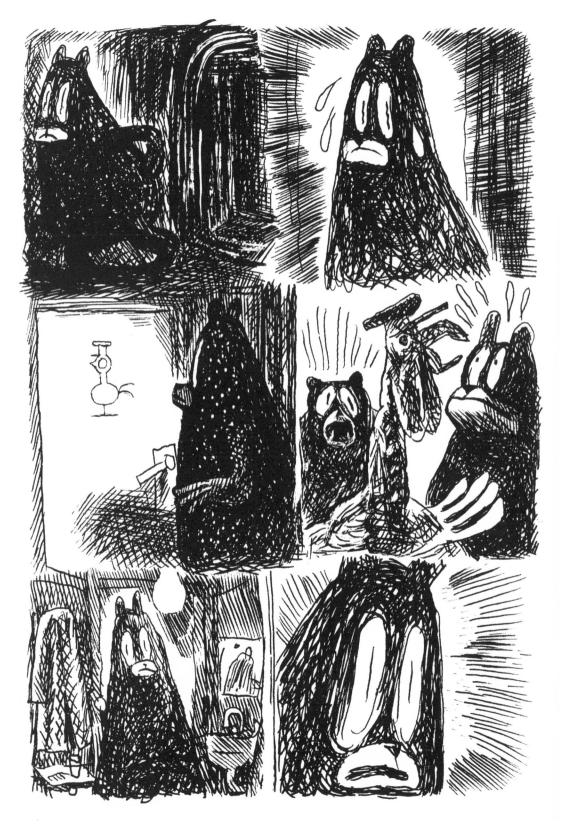

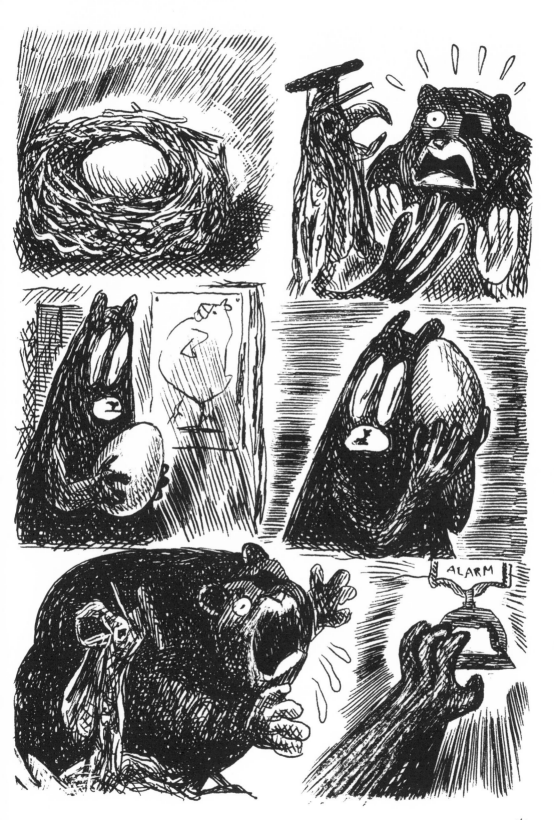

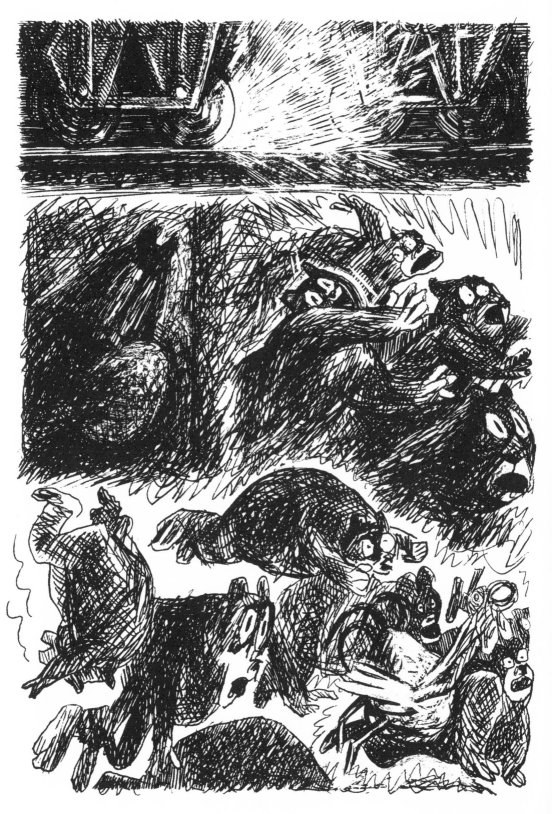

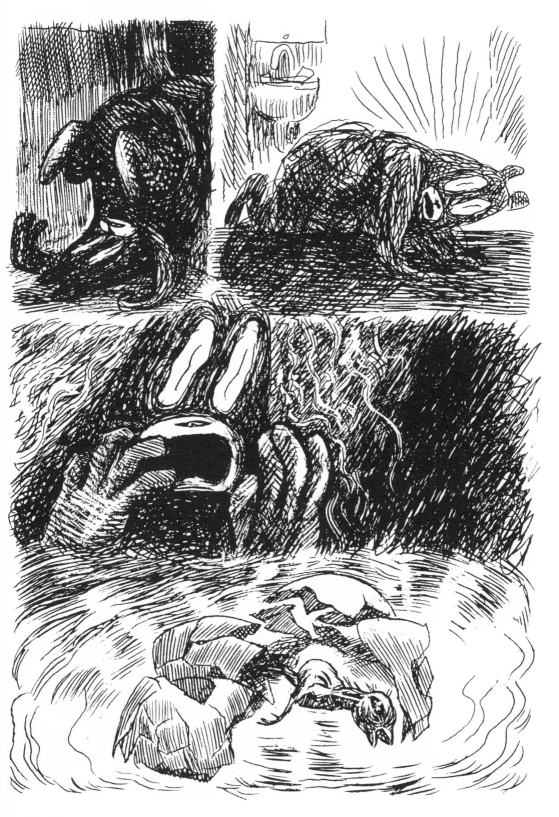

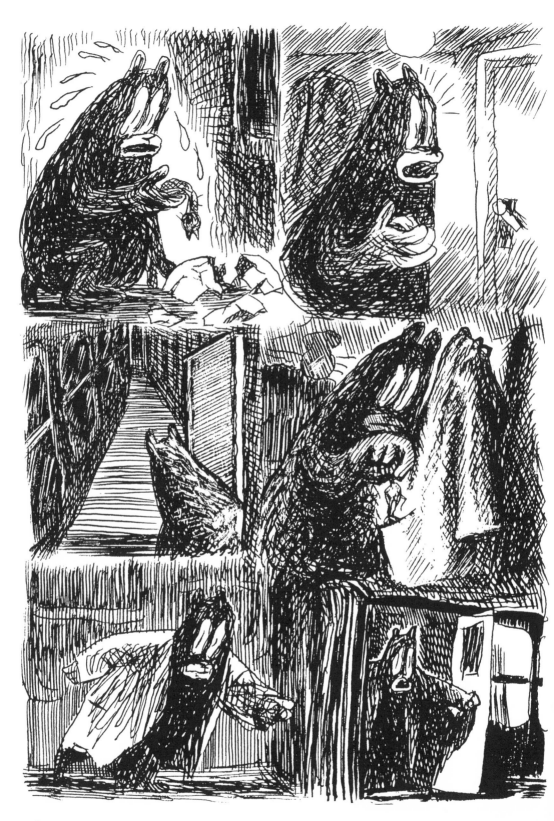

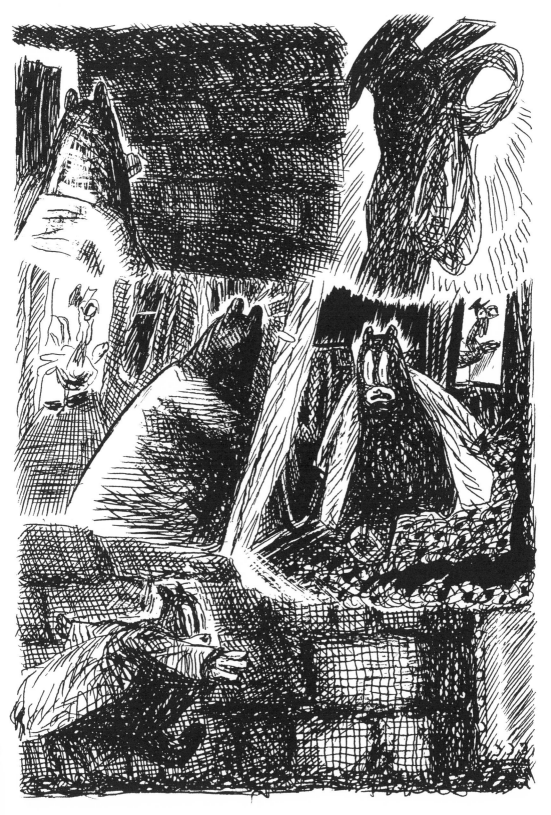

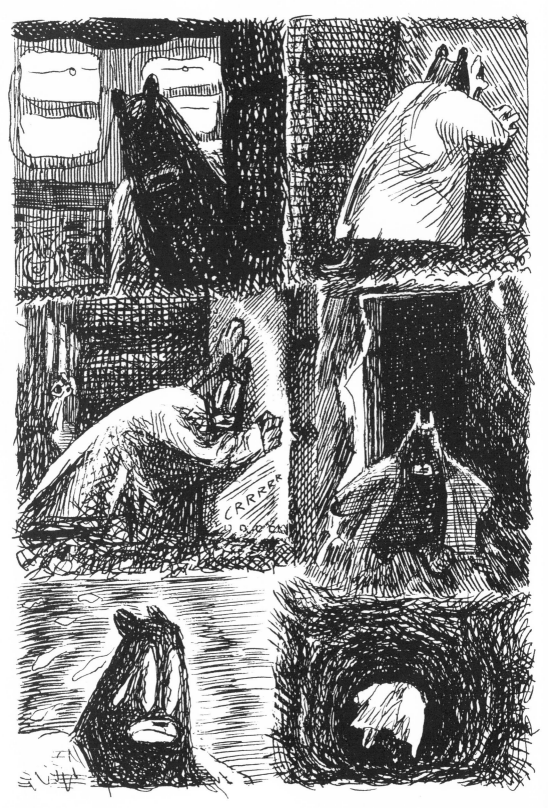

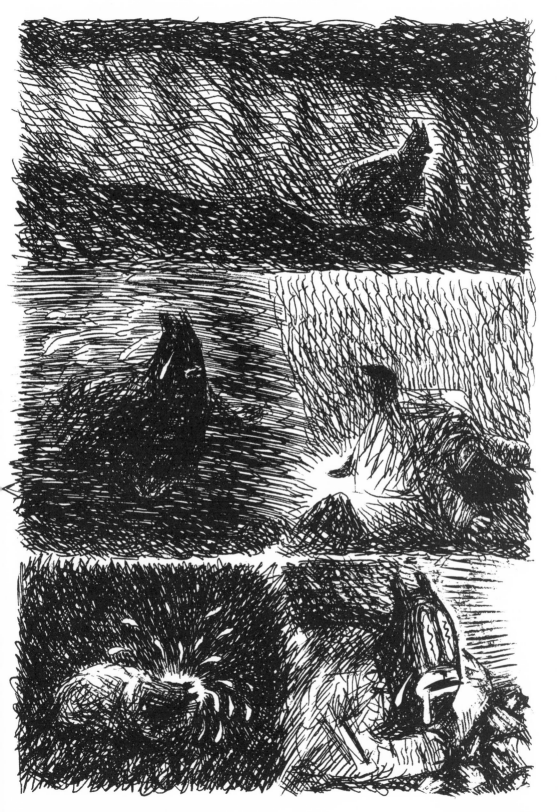

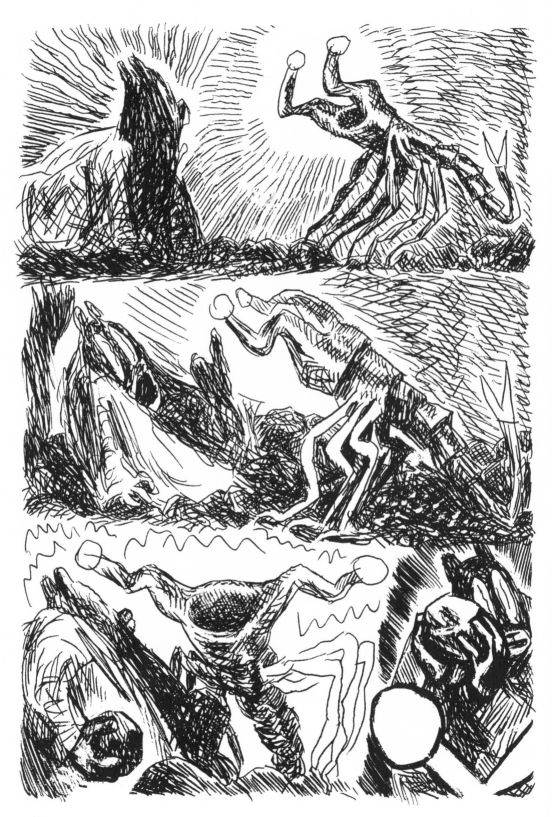

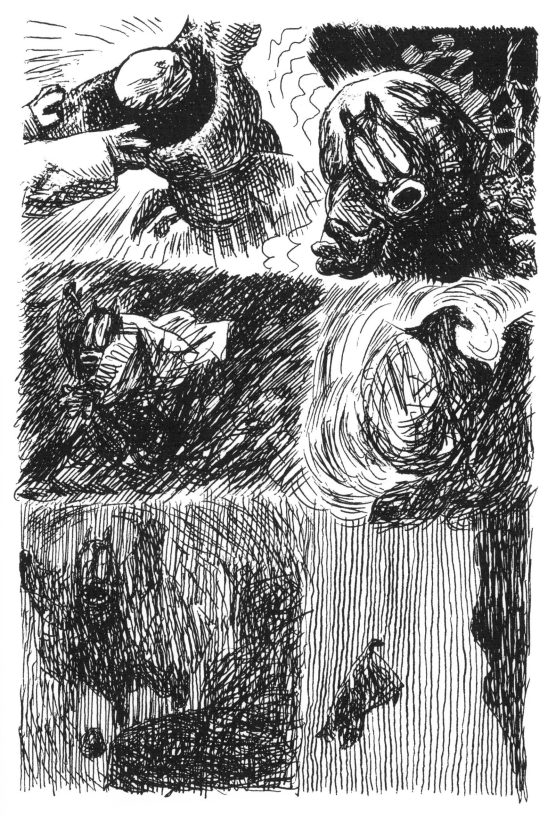

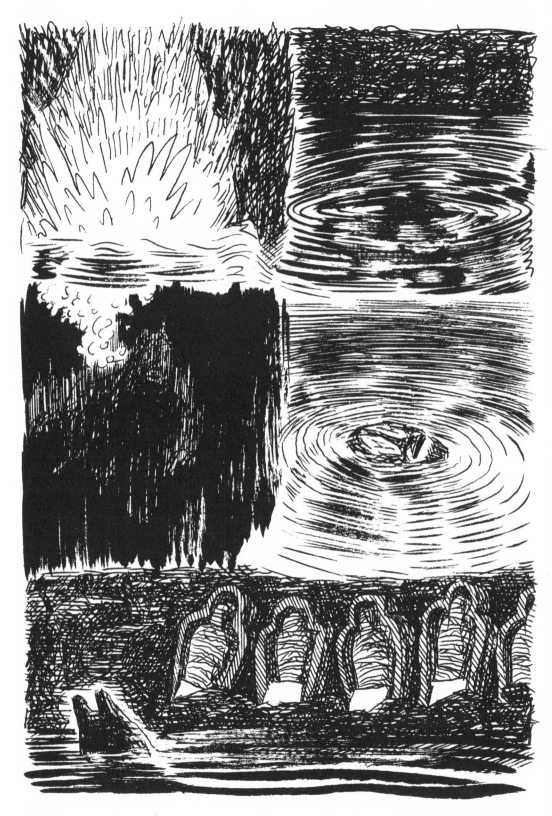

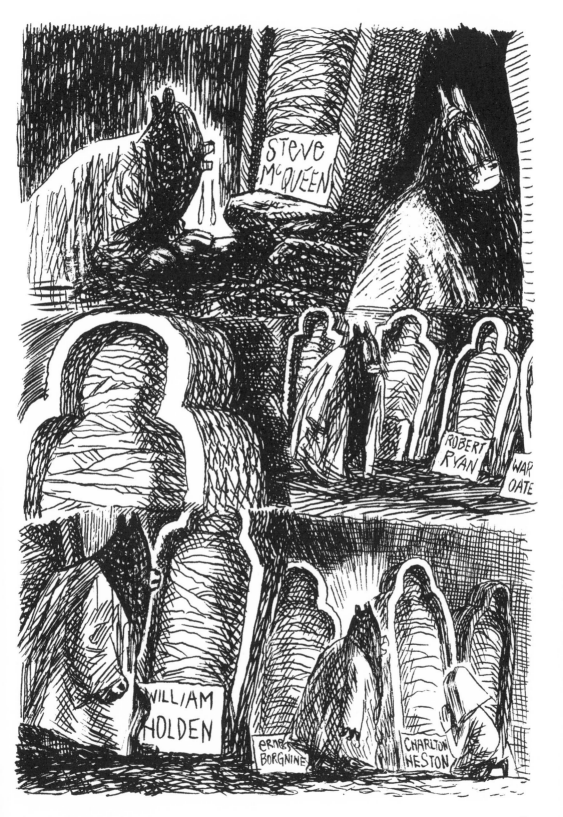

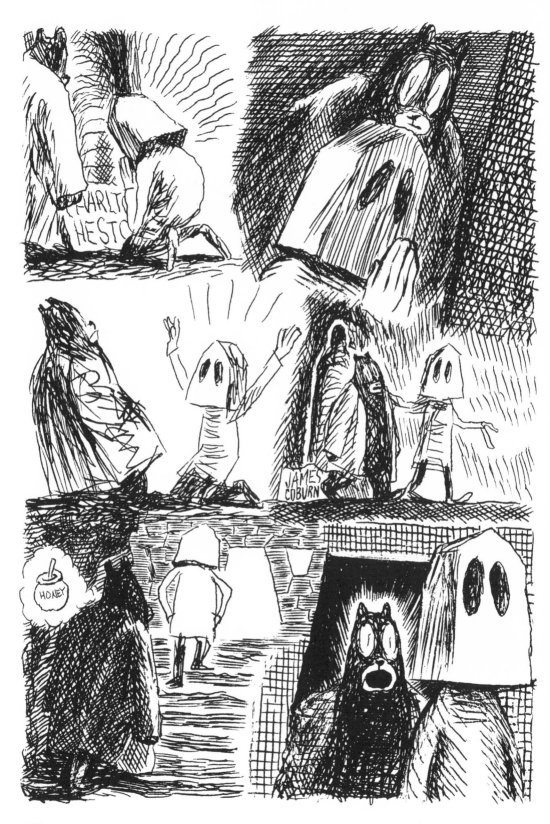

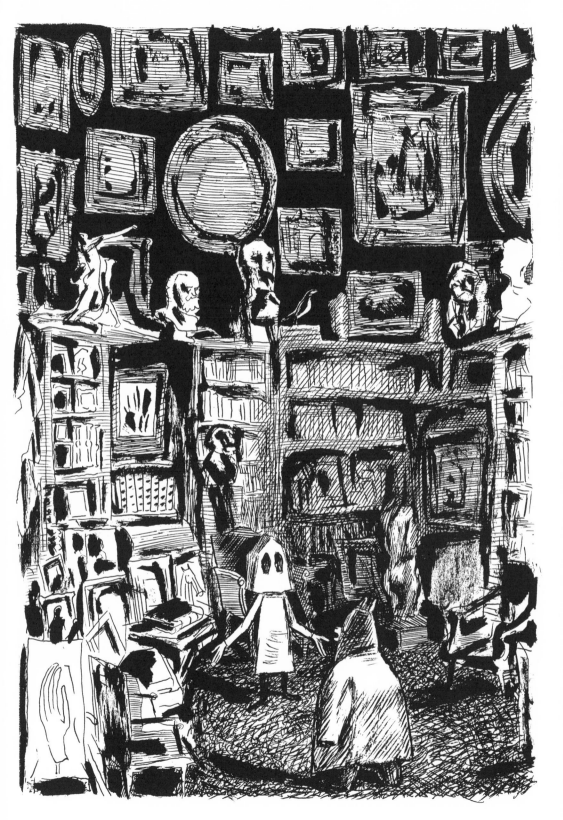

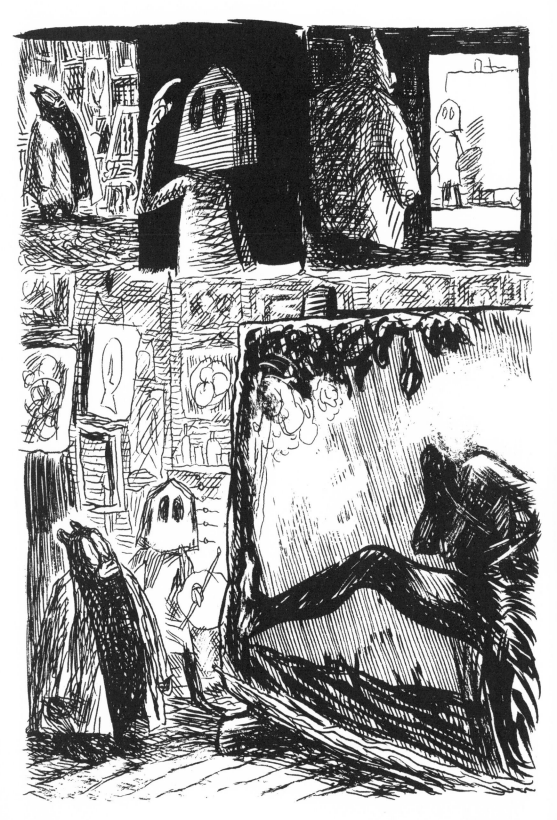

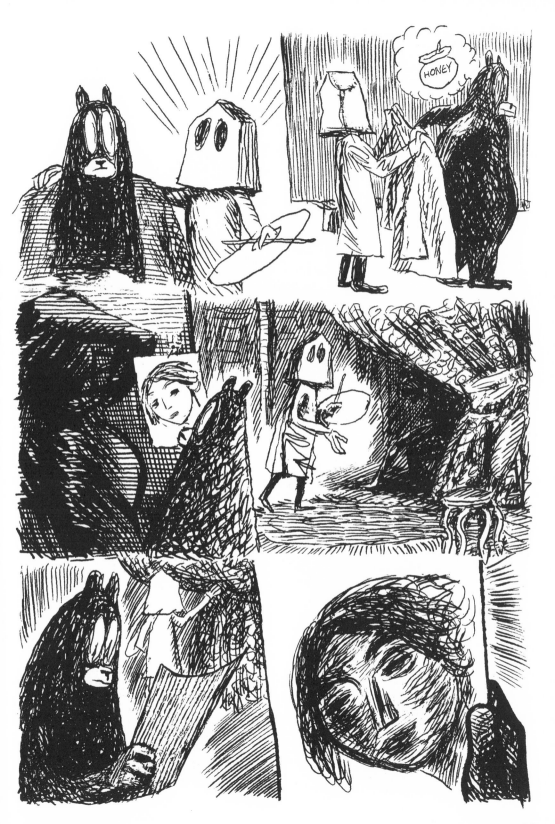

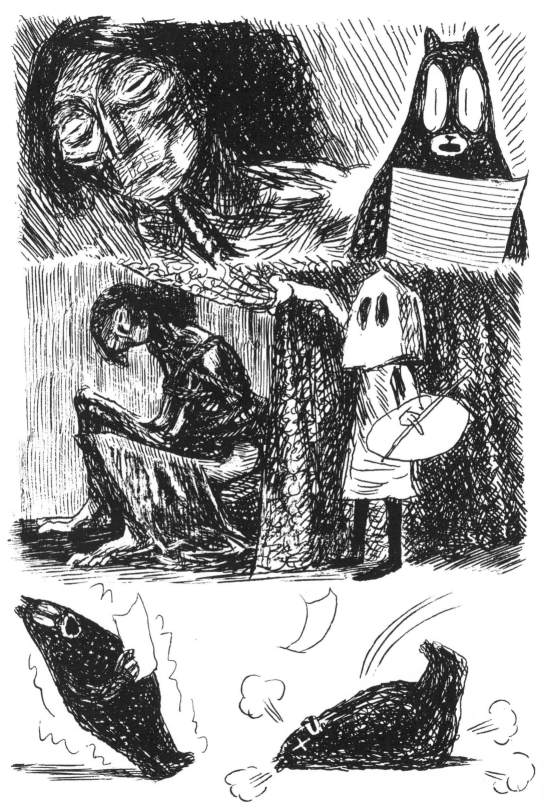

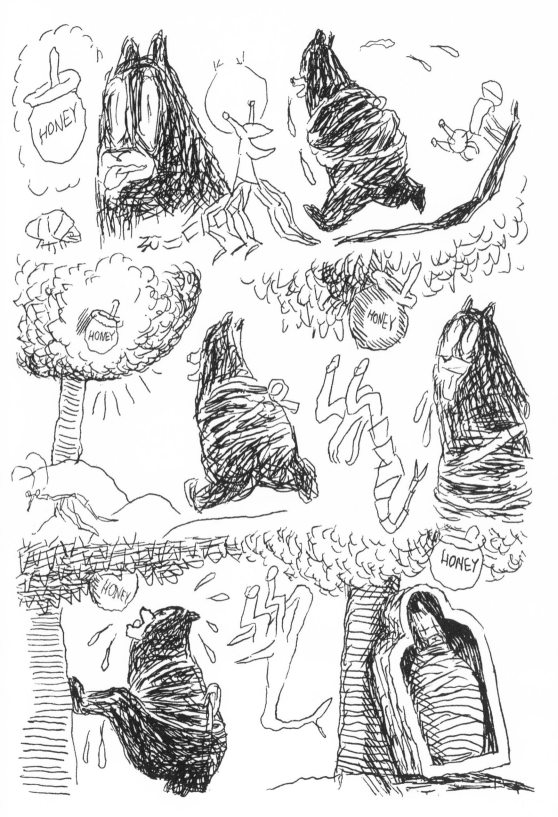

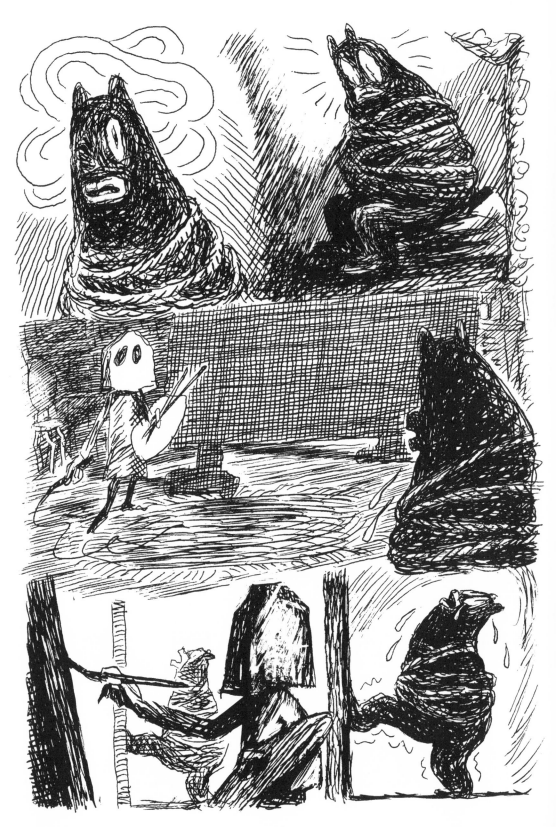

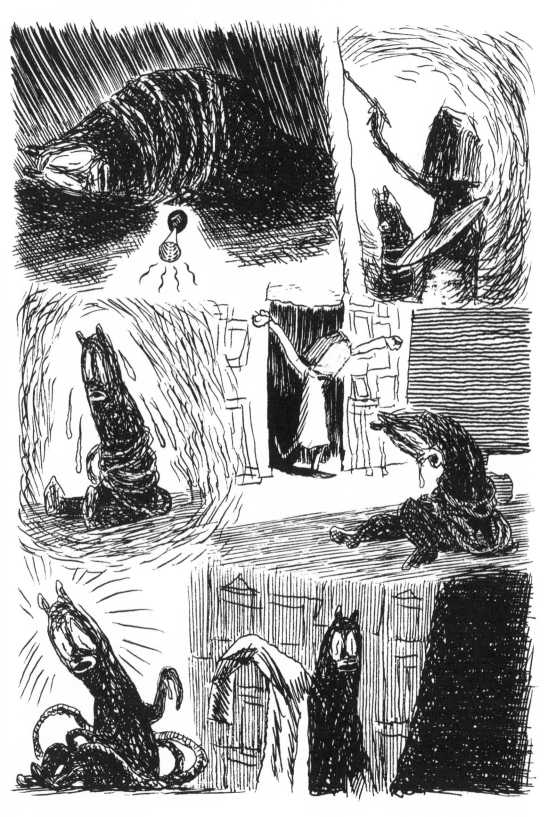

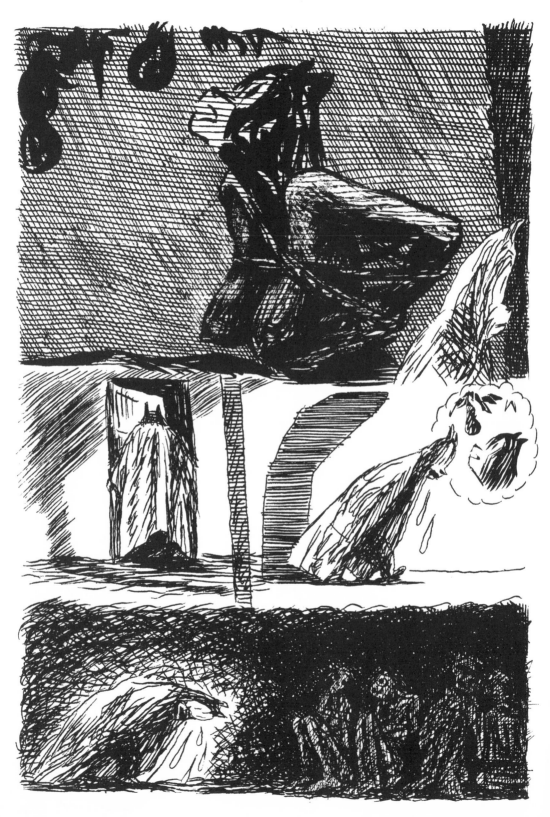

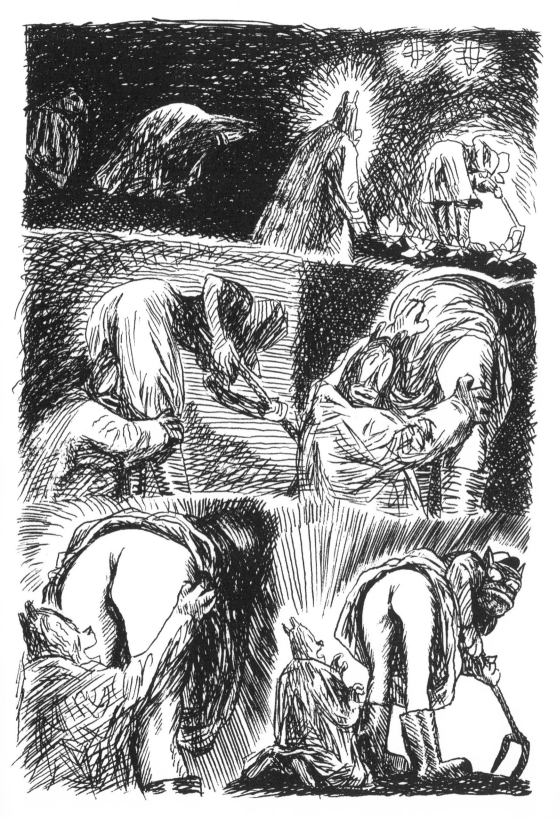

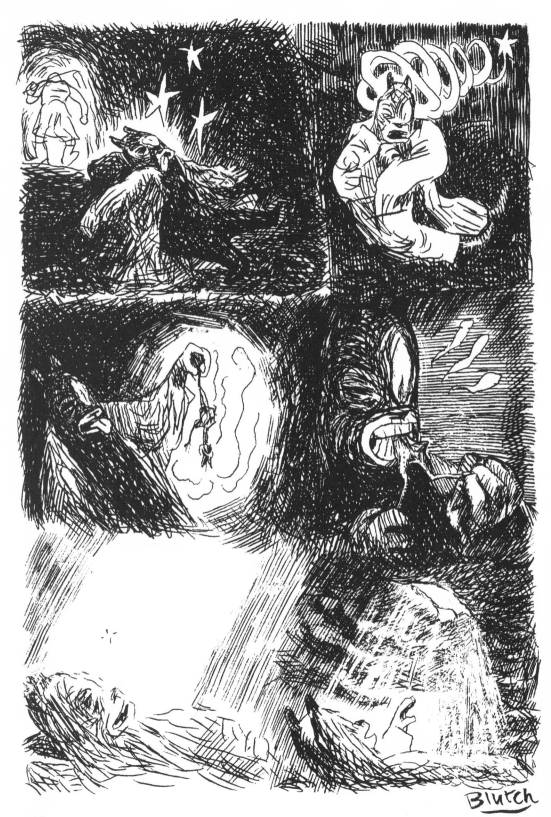

unfinished
and unpublished

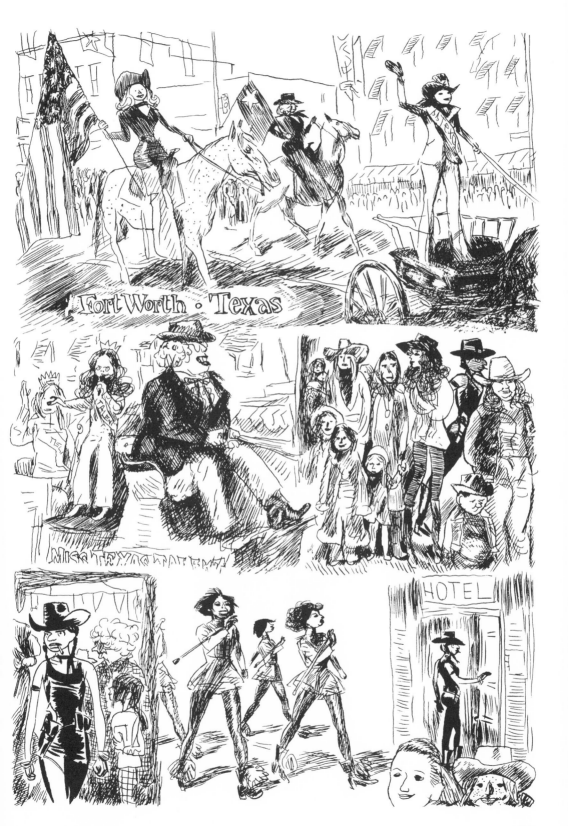

Fort Worth · Texas

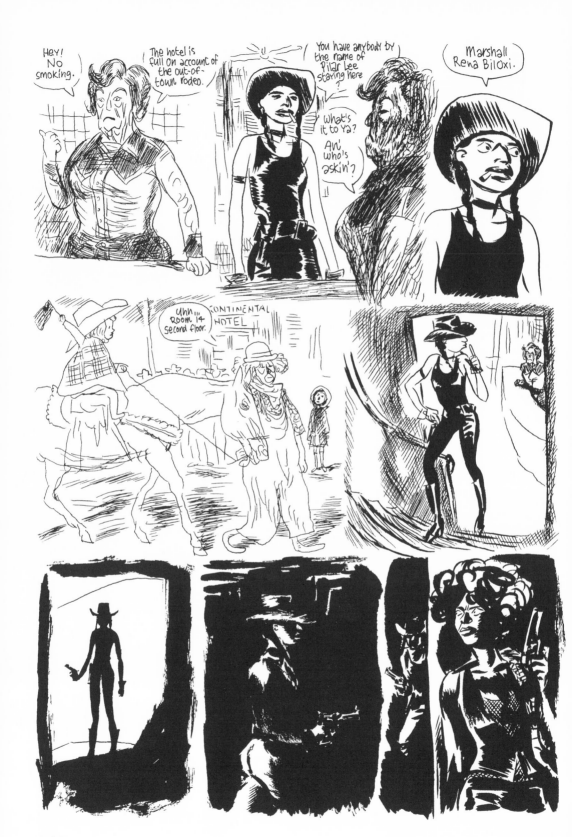

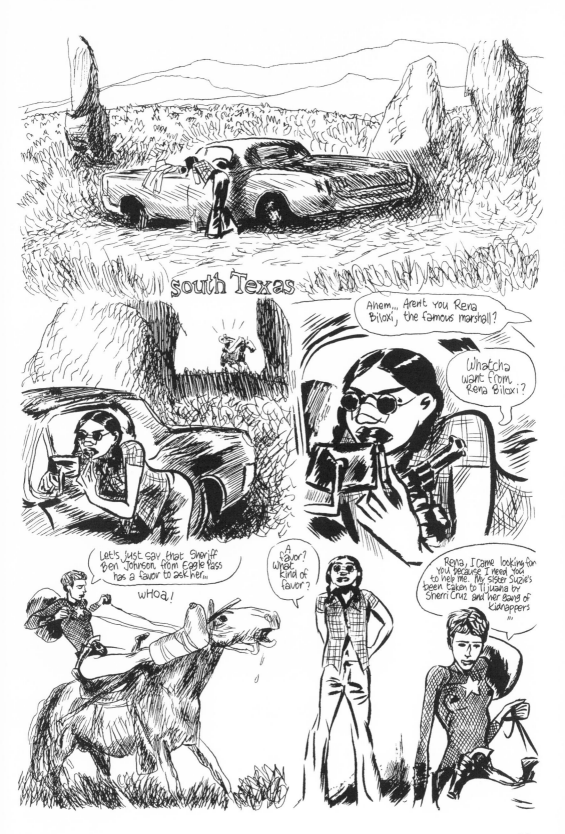

south Texas

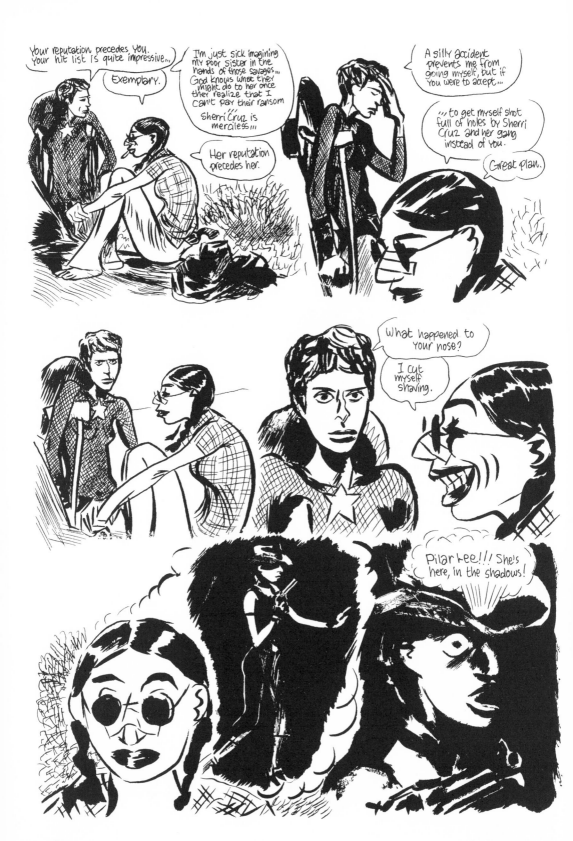

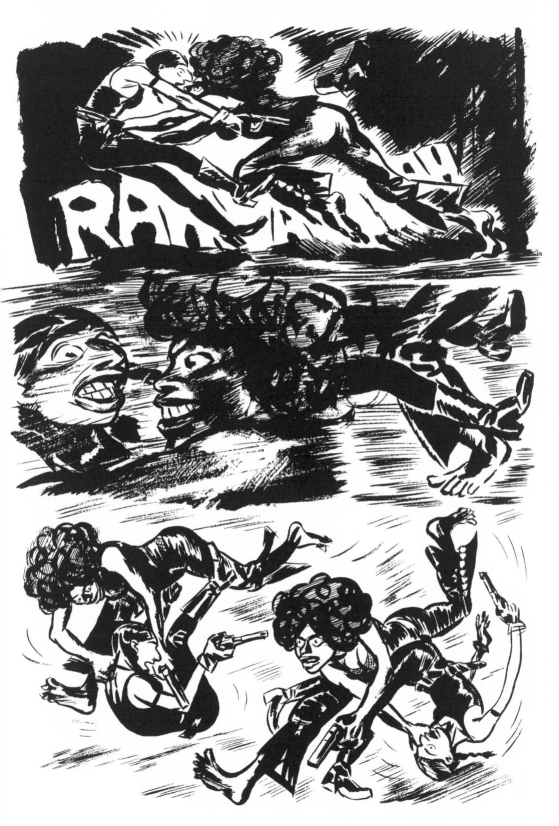

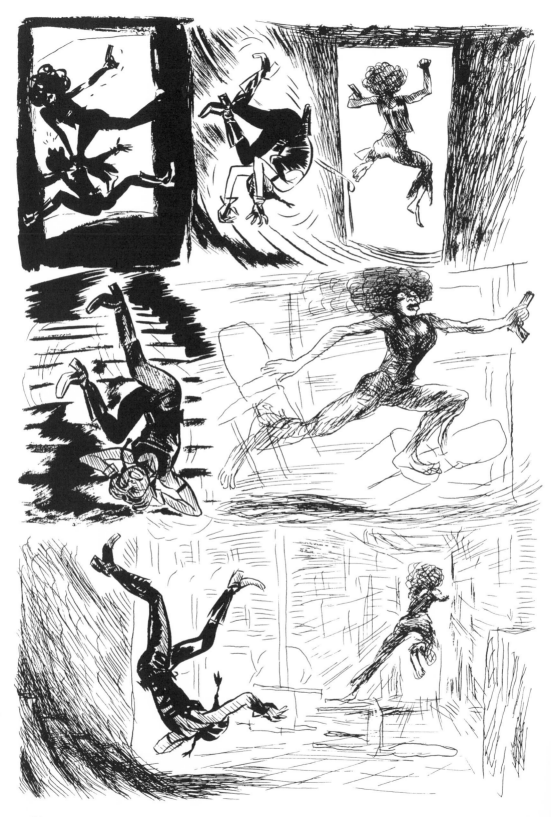

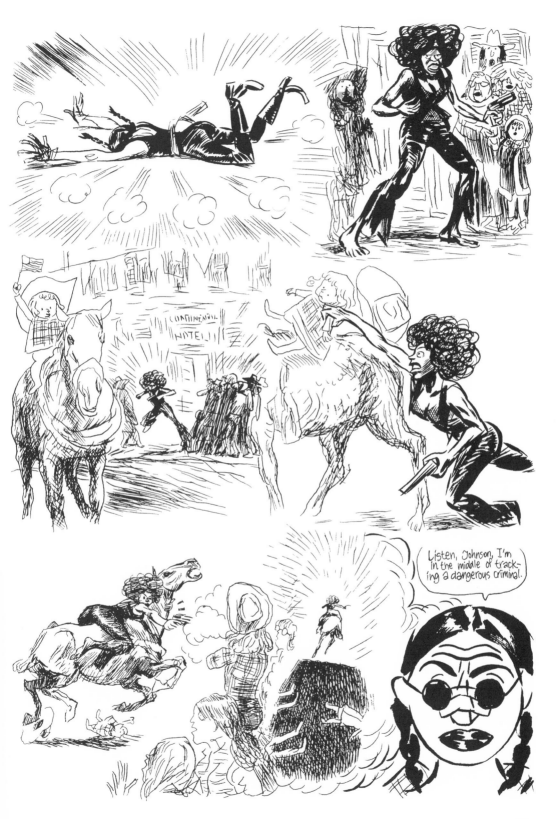

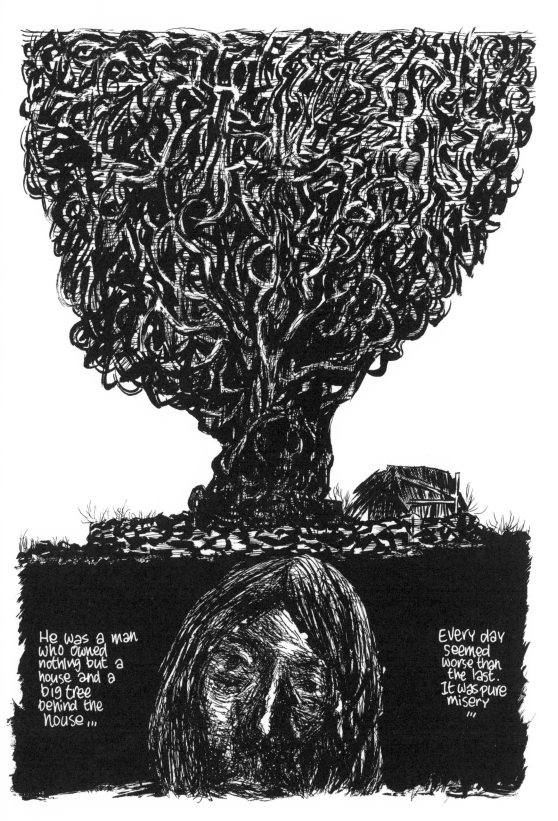

He was a man who owned nothing but a house and a big tree behind the house...

Every day seemed worse than the last. It was pure misery...

201

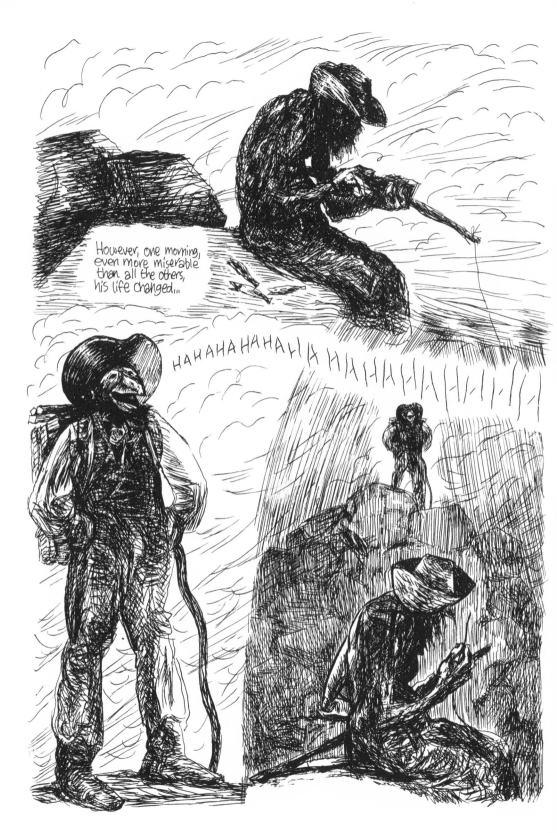

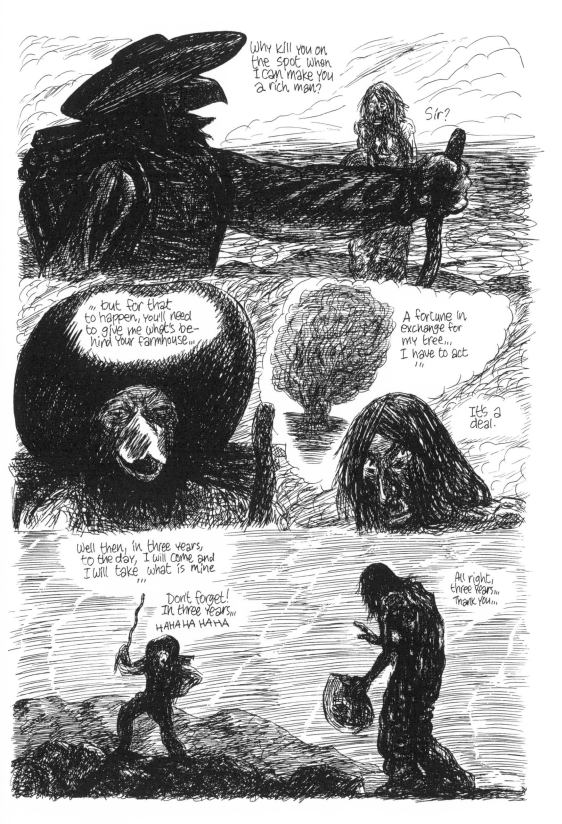

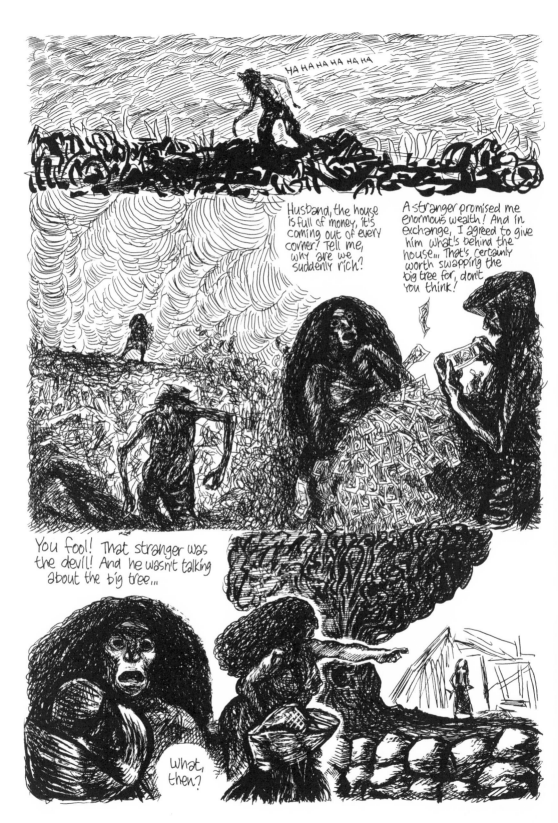

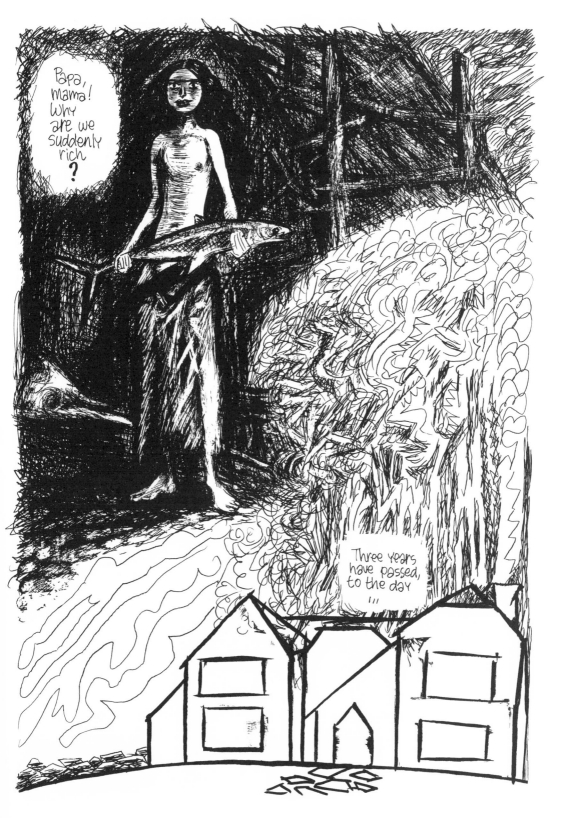

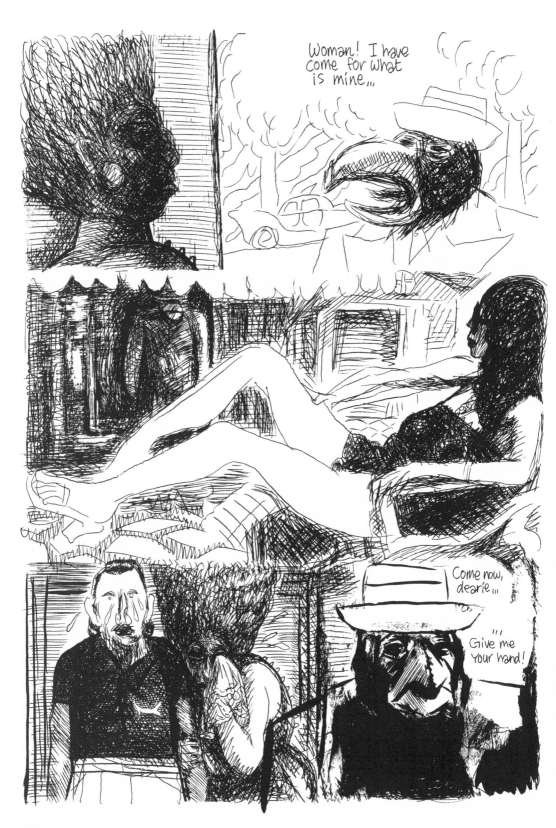

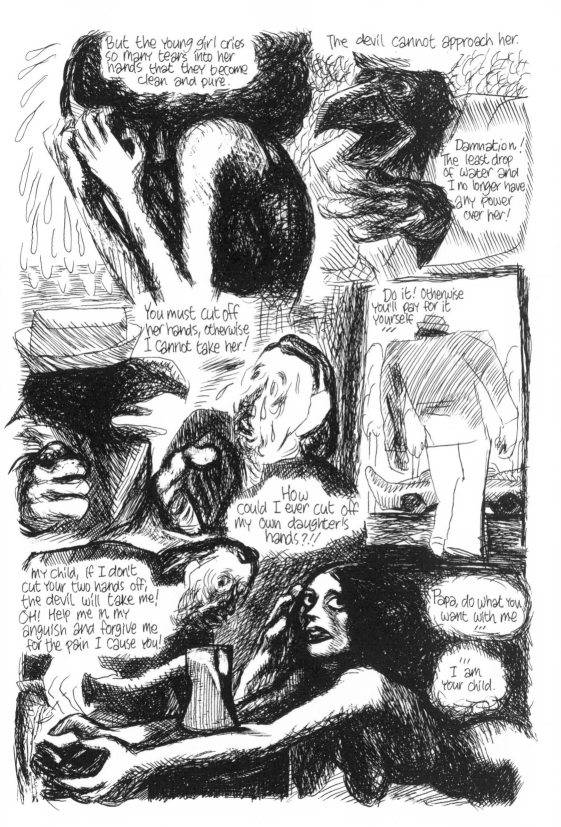

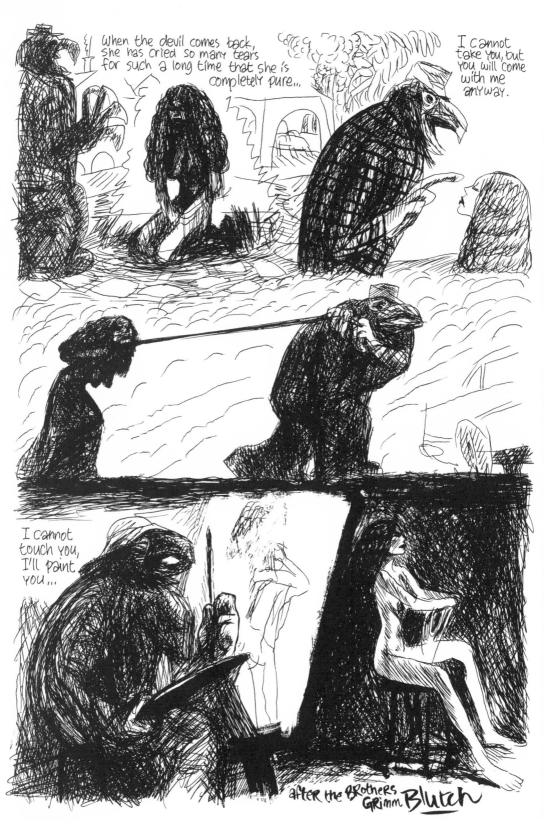

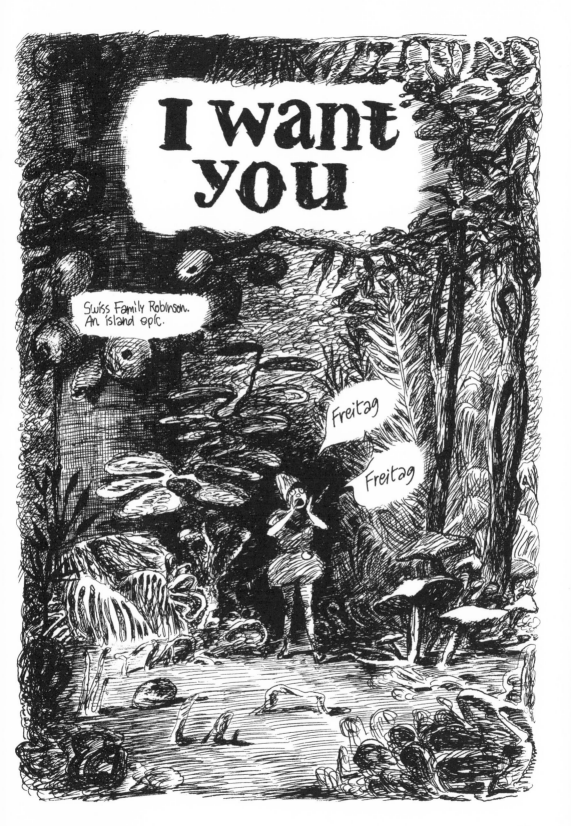

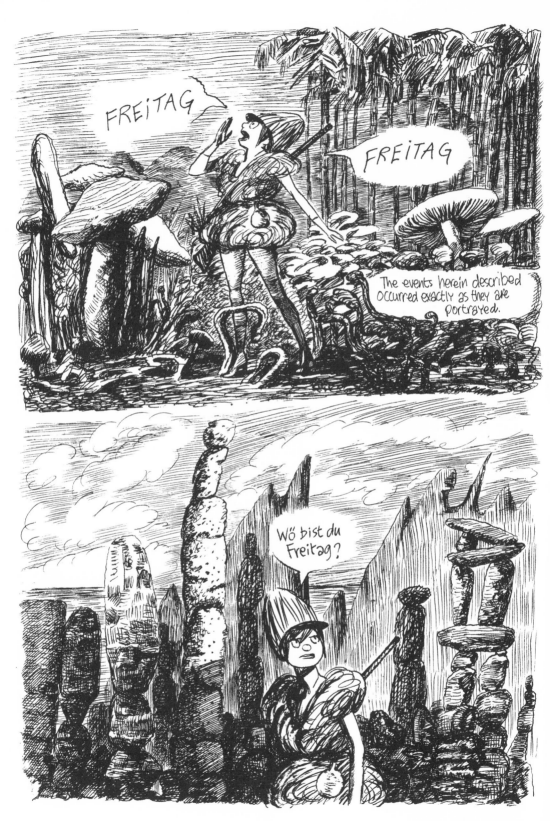

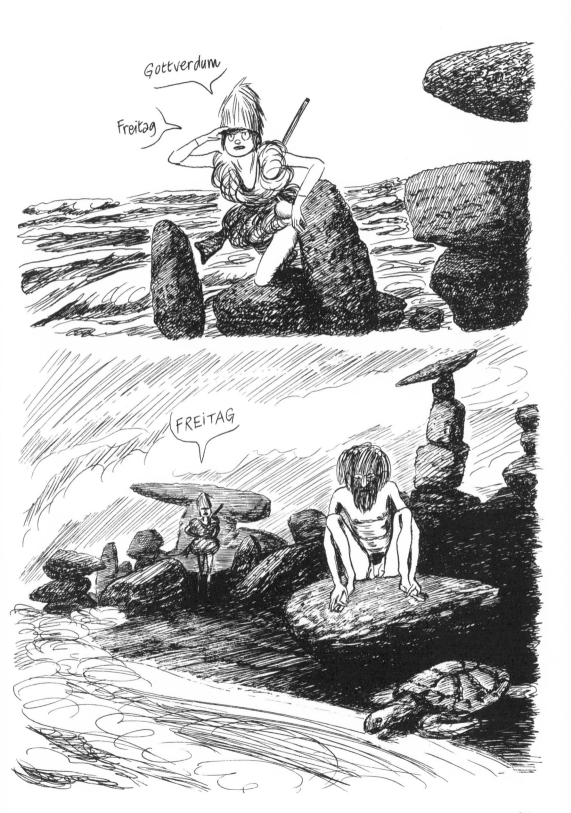

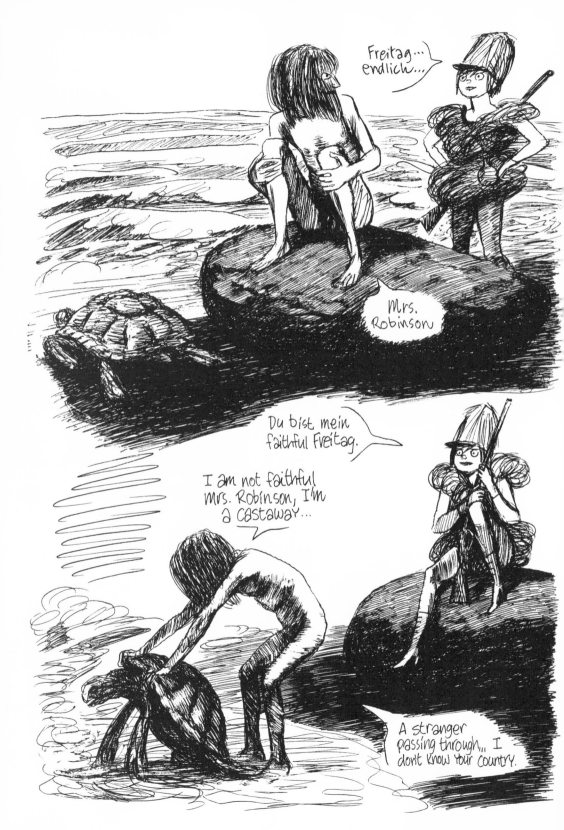

214

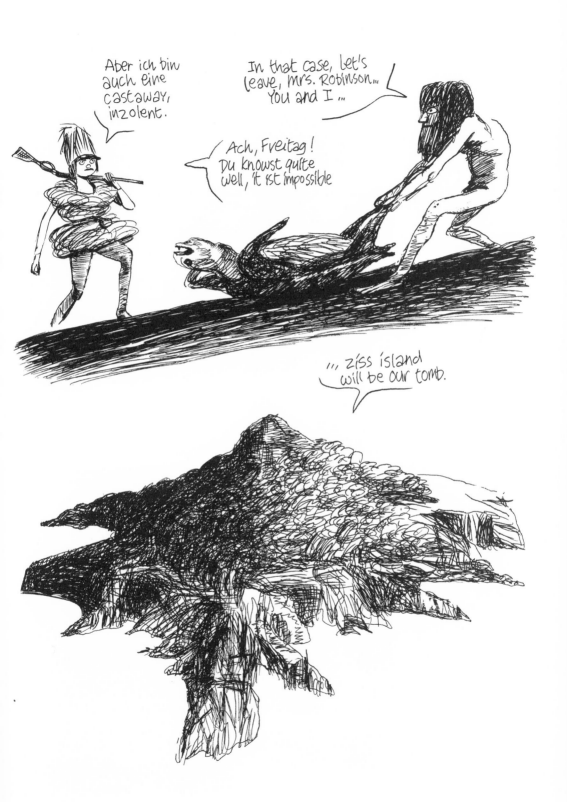

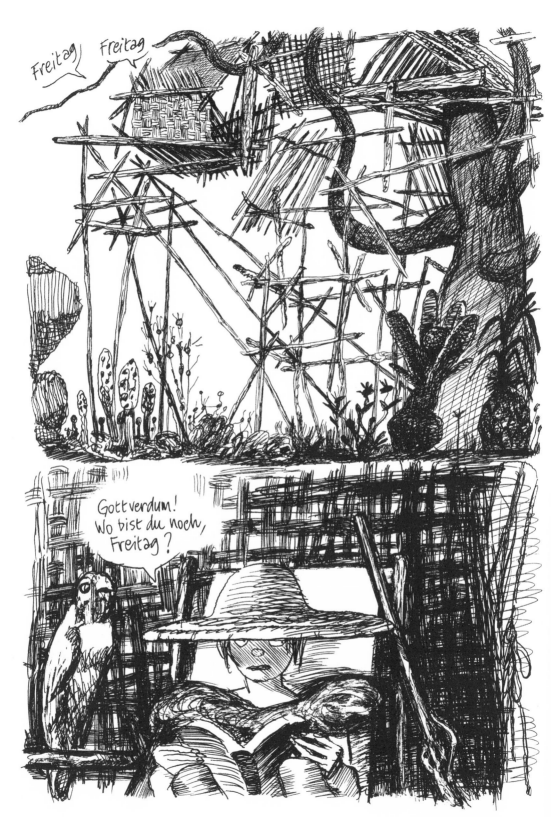

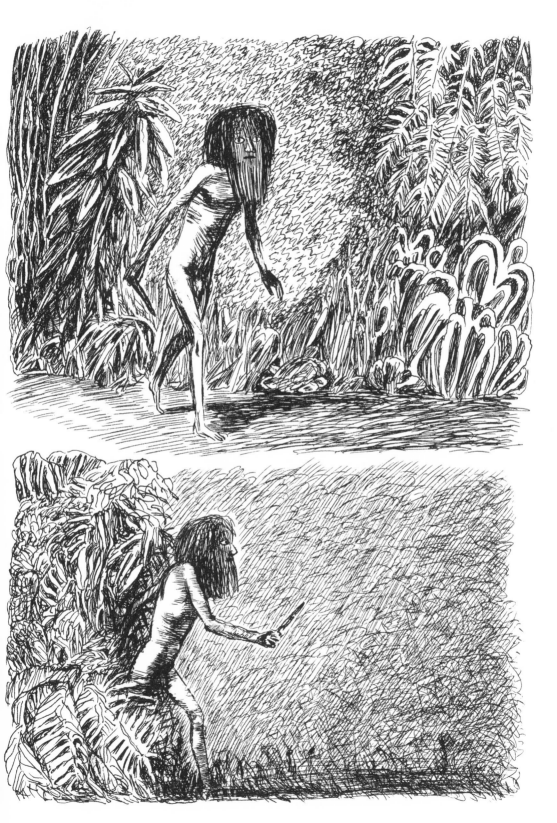

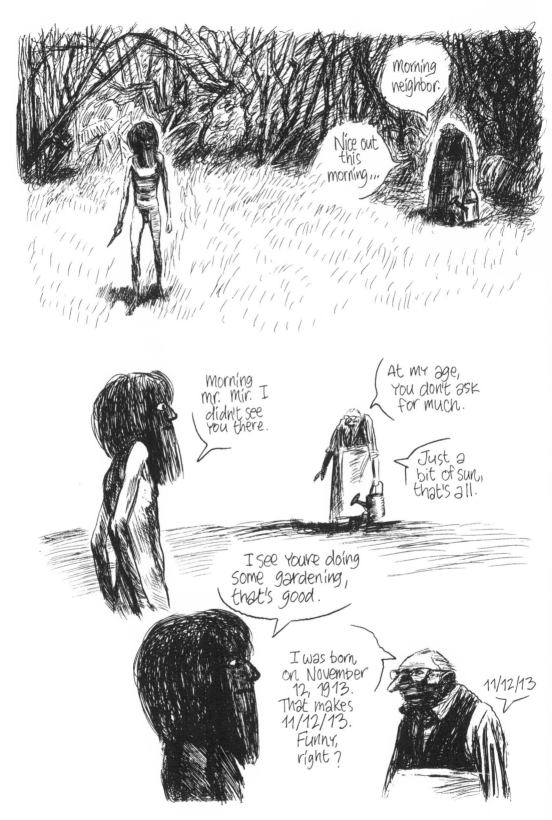

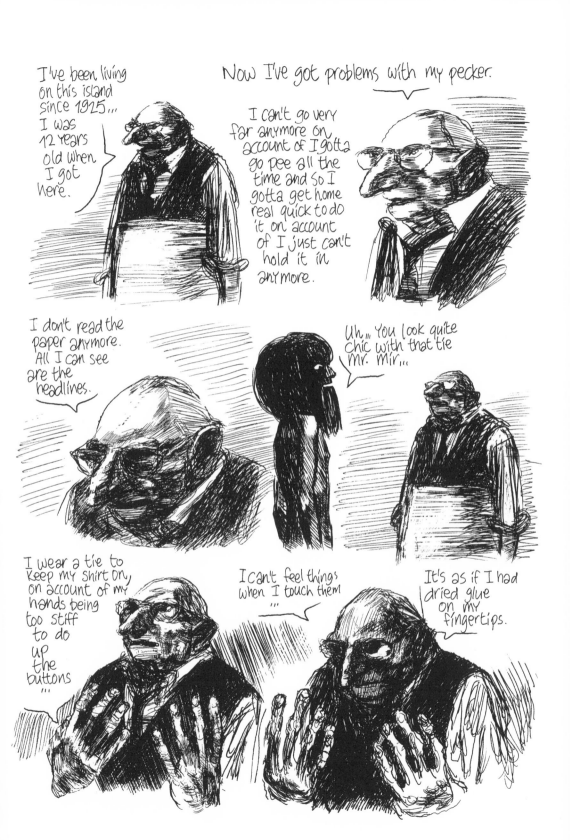

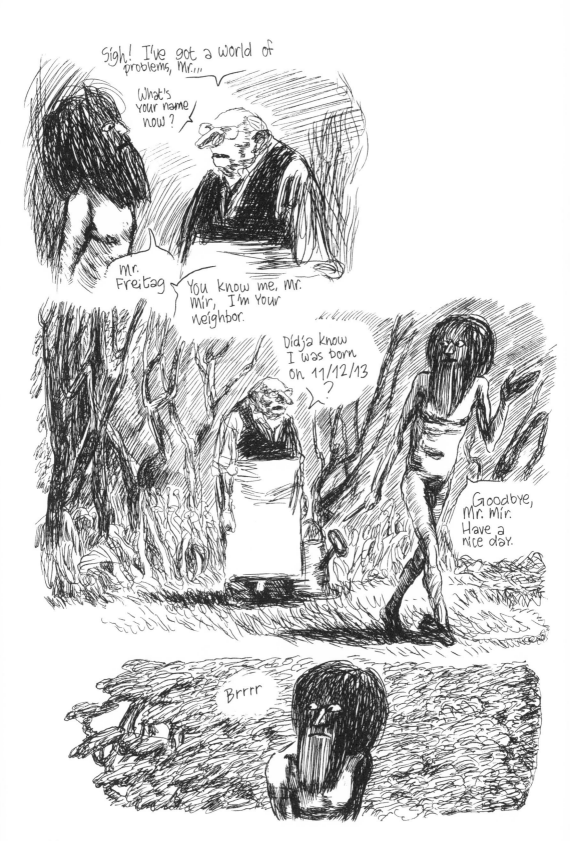

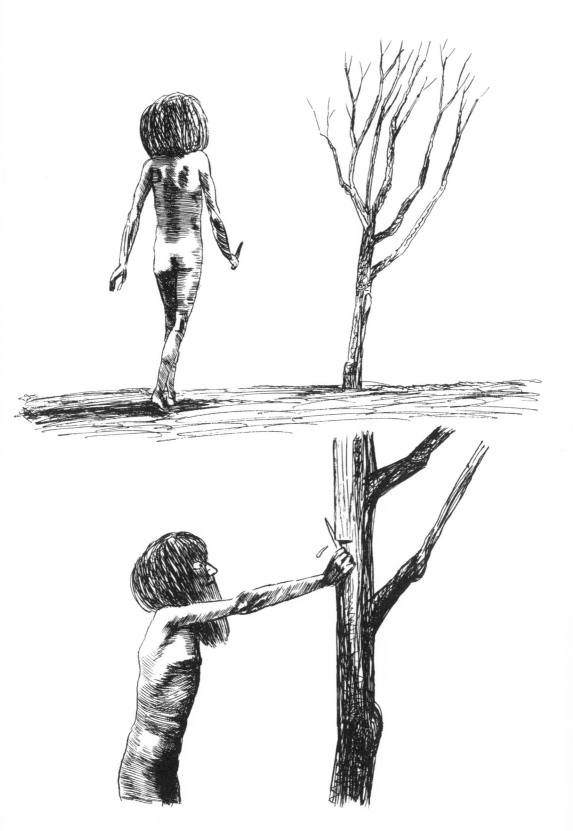

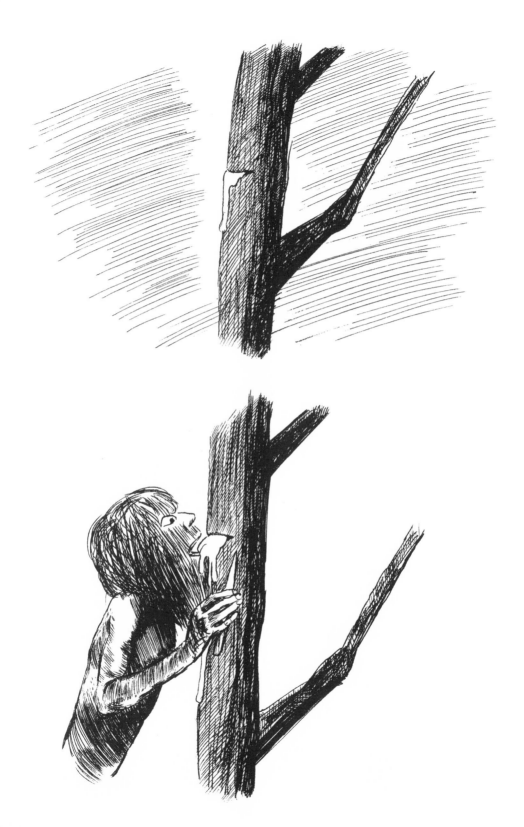

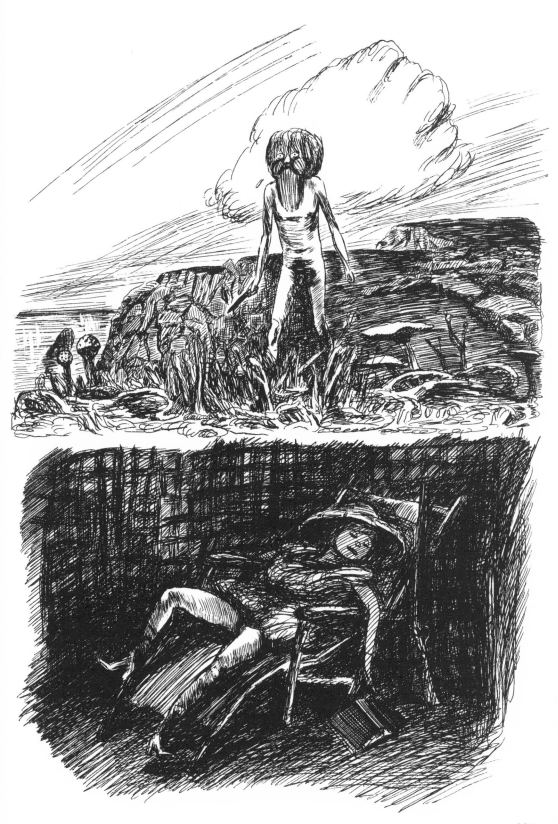

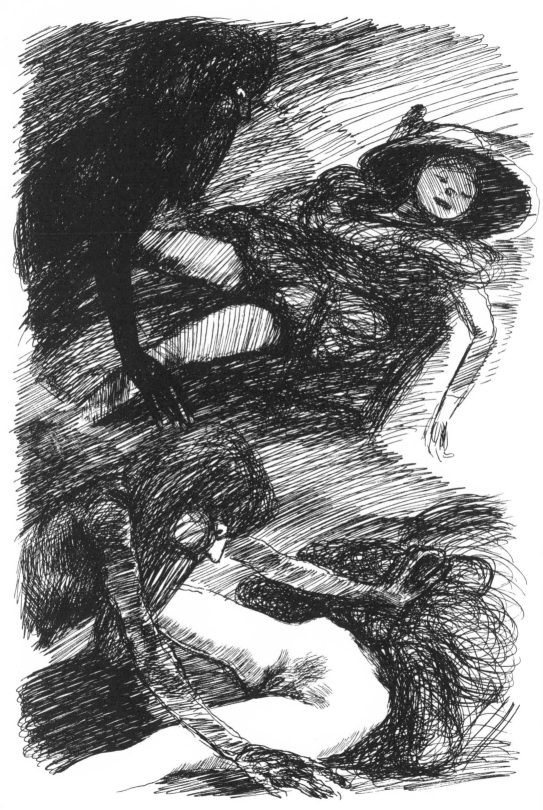

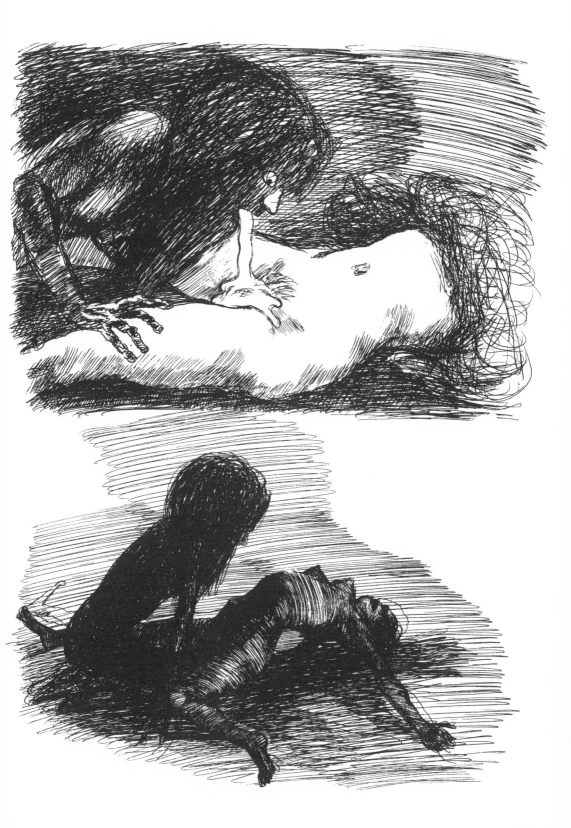

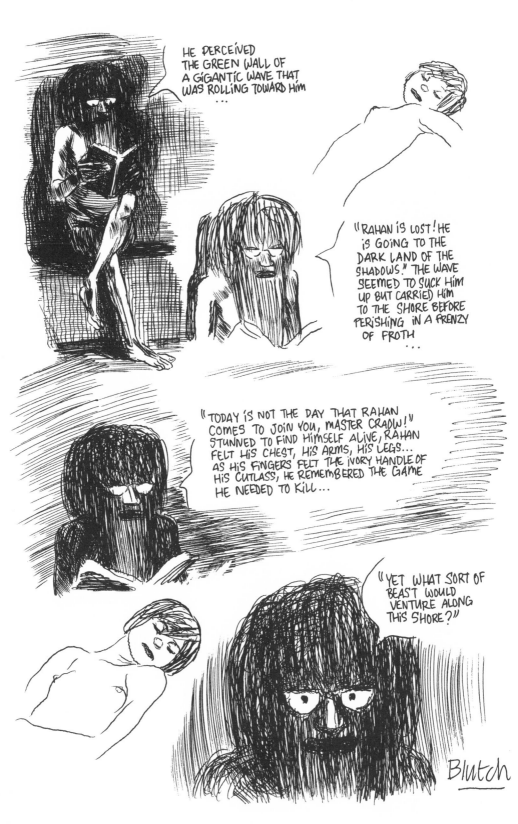

HE PERCEIVED
THE GREEN WALL OF
A GIGANTIC WAVE THAT
WAS ROLLING TOWARD HIM
...

"RAHAN IS LOST! HE
IS GOING TO THE
DARK LAND OF THE
SHADOWS." THE WAVE
SEEMED TO SUCK HIM
UP BUT CARRIED HIM
TO THE SHORE BEFORE
PERISHING IN A FRENZY
OF FROTH
...

"TODAY IS NOT THE DAY THAT RAHAN
COMES TO JOIN YOU, MASTER CRAOW!"
STUNNED TO FIND HIMSELF ALIVE, RAHAN
FELT HIS CHEST, HIS ARMS, HIS LEGS...
AS HIS FINGERS FELT THE IVORY HANDLE OF
HIS CUTLASS, HE REMEMBERED THE GAME
HE NEEDED TO KILL...

"YET WHAT SORT OF
BEAST WOULD
VENTURE ALONG
THIS SHORE?"

Blutch

ALSO AVAILABLE FROM
NEW YORK REVIEW COMICS

YELLOW NEGROES AND OTHER IMAGINARY CREATURES
Yvan Alagbé

PIERO
Edmond Baudoin

ALMOST COMPLETELY BAXTER
Glen Baxter

AGONY
Mark Beyer

PEPLUM
Blutch

THE GREEN HAND AND OTHER STORIES
Nicole Claveloux

WHAT AM I DOING HERE?
Abner Dean

THE TENDERNESS OF STONES
Marion Fayolle

LETTER TO SURVIVORS
Gébé

PRETENDING IS LYING
Dominique Goblet

ALAY-OOP
William Gropper

VOICES IN THE DARK
Ulli Lust

FATHER AND SON
E.O. Plauen

SOFT CITY
Pushwagner

THE NEW WORLD
Chris Reynolds

PITTSBURGH
Frank Santoro

MACDOODLE ST.
Mark Alan Stamaty

SLUM WOLF
Tadao Tsuge

THE MAN WITHOUT TALENT
Yoshiharu Tsuge

RETURN TO ROMANCE
Ogden Whitney